IMAGES
of America

AUBURN

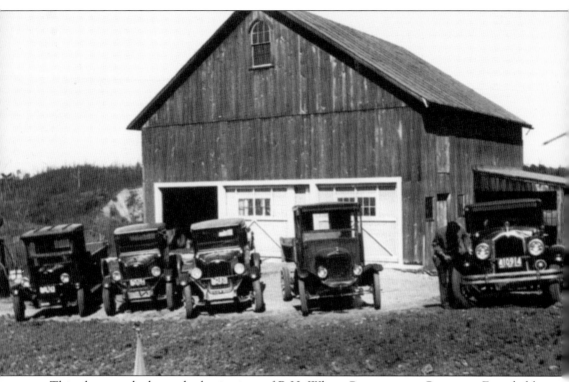

This photograph shows the beginnings of R.H. White Construction Company. Founded by Ralph H. White in 1923, the business has grown and diversified over the years and can boast of having employees who are second- and third-generation workers. Ralph White was also a chief of the Auburn Fire Department. His photograph can be seen in the chapter on civic and service organizations. (Courtesy of the Auburn Historical Museum.)

ON THE COVER: Holstrom's Market was founded in 1907, and this building was constructed in 1909. Expanded many times, this market was one of the first locations in town to have electricity and telephone service. The founders are Andrew S. Holstrom (far left, back cover) and his sons Hjalmar (back cover) and Frithiof "Fritz" Holstrom (front cover). (Courtesy of Kenneth Holstrom.)

IMAGES
of America

AUBURN

The Auburn Historical Society
Foreword by Kenneth Ethier

ARCADIA
PUBLISHING

Copyright © 2014 by the Auburn Historical Society
ISBN 978-1-4671-2066-1

Published by Arcadia Publishing
Charleston, South Carolina

Printed in the United States of America

Library of Congress Control Number: 2013940028

For all general information, please contact Arcadia Publishing:
Telephone 843-853-2070
Fax 843-853-0044
E-mail sales@arcadiapublishing.com
For customer service and orders:
Toll-Free 1-888-313-2665

Visit us on the Internet at www.arcadiapublishing.com

This book is dedicated to all the people of Auburn who contributed to taking the town from its agricultural beginnings to the progressive community of today.

CONTENTS

Foreword 6

Acknowledgments 7

Introduction 8

1. People and Dwellings 11

2. Commerce, Farms, and Mills 37

3. Churches 65

4. Schools 73

5. Sports and Recreation 89

6. Civic and Service Organizations 97

7. Trains, Trolleys, and Pinehurst Park 119

FOREWORD

Auburn is special in many ways. One way it is notable is in the loss of 64 feet of elevation. In the early 1900s, Beer's Hill was dynamited for its boulders. The boulders were fed into a steam-driven stone crusher to create railroad ballast. It ceased operations around 1927. Today's highest point is Crowl Hill, at 882 feet above sea level; it is located about two miles from the remains of the stone crusher.

An Auburn hobo named Bill S. was the self-proclaimed caretaker of the stone crusher and its surrounding area. With the stone crusher's close proximity to the railroad tracks, Bill became the host to many hobos from around the country. These hobos turned Indian-head nickels into works of art to be used as barter for a meal.

Auburn can also boast of Kettle Brook, the single largest tributary of the Blackstone River. Its power was harnessed for textile mills and sawmills. In the 1870s, a silver mine was located in Auburn. The longest railroad grade in New England starts at the Worcester/Auburn line, ending in Charlton seven miles away. Rubbish from Boston's North and South Stations was collected, brought by railcar, and dumped near Auburn's Webster Junction on the Boston & Albany Railroad. Auburndale Spring, located near Webster Junction, supplied water to a famous Boston hotel.

Auburn was also the home to an airport where World War II and commercial pilots received their Civil Aeronautics Administration (CAA) licenses.

Many war heroes claim Auburn as their hometown. R. Boardman Jennison, a Civil War veteran whose headstone reads, "starved at Andersonville," is buried in West Burying Ground. Norman Hall, Chester Tuttle, David Kusy, and David Brodeur, veterans who gave their lives for their country, have memorials named for them.

Our town hall, built in 1897, has housed classrooms for schoolchildren, dances sponsored by the Auburn Grange and held in the selectmen's meeting room, monthly talent shows, occasional plays featuring the selectmen as the actors, and a gun range in the cellar. The outhouse was moved to Hillside Cemetery and is currently used as a tool shed.

—Kenneth Ethier
Auburn Town Historian

6

ACKNOWLEDGMENTS

This book would not have been possible without the concentrated effort of many people. First and foremost, we are grateful to Fred Mirliani of the Photographic Preservation Center. Fred grew up in Auburn and, like many former residents, still has great affection for his childhood home. He has put in hundreds of hours digitizing photographs and advising us on which ones to use. Richard Hedin, a lifelong Auburnite and talented photographer, has also been an enormous help in the digitizing process. Robert Breault advised on layouts and photographed some items for inclusion in this book. We particularly want to thank Clifford Granger and Harry "Sid" Mason, who came in many times to identify photographs and share their memories. They are both remarkable nonagenarians. We also want to thank the many people who brought in cherished family photographs and their stories, as well as those who helped during the research and organization of this book. We wish we could have used all of the photographs; be assured that all those we received were carefully digitized and are now part of the Auburn Historical Museum's archives, available to anyone who wants to come in and see them. Our museum has a large assortment of artifacts and documents as well, and we hope all the readers will come to visit us some day. We are grateful to all those who donated toward the production of this book, especially the White Companies Charitable Trust, Patricia Bukoski, and Auburn High School's class of 1961. Unless noted with a credit line, the images are from the collection of the Auburn Historical Museum. Thank you to the following: the Frank Allen Collection, Janice Andrews, Philip Becker, Pauline Belair, Bethel Lutheran Church, Ronald Bonzey, Anthony Brooks, Janice Webster Brown, Patricia Bukoski, James D. Carr Jr., Chester P. Tuttle Post 279, Elaine Doherty, Barbara Ela, Ellen and Ken Ethier, Gail Farley, the Fortin family, Paul Govoni, Clifford Granger, Jack and Gail Haroian, Robert Haroian, Katherine Champagne Heard, Kenneth Holstrom, Elizabeth Johnson, Robert Johnson, Stanley Johnson, Maryann Kosciusko, Donna LaCroix, Roger and Rosalie LaCroix, Harry "Sid" Mason, Diane Stone Moore, Irene Morrow, Robert Murray, Daniel O'Shea, Robert Pearson, David Peckham, Joseph Poirier, Donald Post, Ronald E. Prouty, Alice Rea, David Rose, Donald Soponski, Earl Standring, Catherine Staruk, Dorothy Tomlinson, Raymond Twarowski, Deborah Virgilio, Richard Warren, and the R.H. White Construction Company.

INTRODUCTION

The first English settlers arrived in Auburn in 1736. The area's proximity to Worcester, Oxford, Sutton, Leicester, and rivers such as Kettle Brook made it a desirable place to be. The Nipmuck Indians had visited the Pakachoag section of town for years, planting their crops in the spring and enjoying their harvest before moving on. During King Philip's War, Metacomet (King Philip) came to speak with Horowannit (known also as Sagamore John), the constable of the Pakachoags, about joining his war to rid the area of the English settlers. The Reverend John Eliot, who preached to Indians all over Massachusetts, came to the region in the 1670s and converted the approximately 100 tribal members to Christianity. It was to the same area that Daniel Bigelow, Ephraim Curtis, Benjamin Wiser (a Native American), David Bancroft, Gershom Rice, Jonathan Stone, and Peter Slater came. Other English settlers arrived, setting up small water-powered grist- and lumber mills and harvesting trees—particularly cedar— for shipment to England.

John Crowl, a captain of the Continental Army and commander of the local minutemen, settled what became known as the Crowl Hill area—the Rochdale Street area near Leicester. Jesse Eddy went to the Prospect Hill region, and Thomas Drury set up his tavern near what became the town center. Starting in 1742, residents began petitioning to become a parish of Worcester. The law required that everyone attend church on Sunday or face legal sanctions, and local residents were finding it difficult to get to services because of the distance. After many attempts, the request was granted in 1772. Parts of Worcester, Oxford, Sutton, and Leicester were appropriated to make South Parish of Worcester, an area of land comprising 15.7 square miles shaped like an irregular pentagon. As township status could not be granted until the local populace could afford its own minister, residents took until 1778 to become a town. By this time, there were about 50 families in town. They were mostly farmers who spent the winters making shoes in their homes to make ends meet. By 1781, there were 64 houses, 5 mills, and the tannery. In 1778, Maj. Gen. Artemas Ward retired as Washington's second-in-command in the Continental Army. He became the head of the Massachusetts courts, and as there was no Massachusetts constitution at this time, he was the de facto governor. To honor him, South Parish chose the name of Ward.

Ward sent 26 men to the Revolutionary War, most notably Daniel Bigelow's son Timothy, who had a distinguished military career in the Continental Army. Jonah Goulding, a veteran of the Revolutionary War, purchased a tannery in the area in 1777. He is most famous for bringing a contingent of men to Worcester as part of Shays' Rebellion. Daniel Shays was outraged that the veterans had not been paid for their service and were consequently losing their homes to foreclosure. He also objected to the taxes being levied, especially on veterans, and to the unstable currency. Jonah Goulding supported this viewpoint and marched on the court in Worcester, intent on stopping its activity. He actually prevented Artemas Ward from holding court and, for his participation, was sentenced to death. He hid out in the woods of Ward for some time until he was pardoned by John Hancock. Afterward, Goulding, a member of the state militia, served as a selectman and as a member of the school committee. He died in 1826 and is buried in West Auburn.

By 1801, Auburn had 79 houses, 7 mills, a potashery, and the tannery. Over time, the residents of the nearby town of Ware became increasingly agitated when Ward's mail kept showing up in

their post office. In 1836, Ware postmaster M.G. Pratt wrote a heated letter citing "insufferable difficulties continuously arising" over the confusion between Ware and Ward and demanding that Ward change its name. In 1837, Ward became Auburn. No one is certain of the inspiration for the new name, but the prevailing theory is that it came from the poem "The Deserted Village" by Oliver Goldsmith. The opening line is "Sweet Auburn, loveliest village of the plain." Actually, Auburn comprises of a number of hills and valleys, with very little plain to speak of. Another theory is that the name was taken from Mount Auburn Cemetery in Cambridge, Massachusetts. Several members of the Stone family were at the dedication of this beautiful site, which lends credence to this theory. Stagecoaches made stops in town to carry passengers to Providence, Worcester, Boston, and Hartford. More information on Auburn transportation will be found in the chapter on trains and trolleys.

One of the long-gone businesses was a brickyard on West Street that was active from the 1700s through the 1800s. It was abandoned by the early 1930s, and there was a legend among local children that, upon completing its construction, the builder had put a silver dollar at the top of the chimney used to fire the bricks. Attempts were made to scale the inside of the chimney, including one by Harry "Sid" Mason and his friends. After failing to reach the top by climbing protruding boards, the boys gave up. When the parents found out, that was the end of treasure hunting at the old brickyard. Near this spot in the 1920s and 1930s, on the corner of West Street and Southbridge Street, was J.B. Garland's feed store. It was a long building, and it had "Auburn" painted on the roof so airplanes knew where they were.

In 1870, an open-pit gold mine was located near Albert and Blaker Streets in West Auburn. The ore was loaded on a freight car on the Boston & Albany Railroad and shipped to Newark, New Jersey, for smelting. There were also very small silver and copper mines in the vicinity, but they and the gold mine played out very quickly. A tailing, or sample rock—complete with specks of gold—can be seen at the Auburn Historical Museum.

The airport opened in 1939. It was privately owned, and many men who went on to become pilots in World War II trained there. Most notable among them was part-owner Ralph Conroy, who became the pilot and driver for General MacArthur, General Eisenhower, and President Truman. The airport ceased to function when Ralph Conroy died in 1953. The field became the Auburn Drive-In Movie, and it is now the site of a Home Depot and BJ's.

The most notable event in Auburn's history was the world's first liquid-fueled rocket launch on March 16, 1926. Dr. Robert Goddard, a professor at Clark University, used his distant cousin Effie Ward's strawberry and cabbage farm as his launching pad. In all, he launched nine successful rockets from her property, with many failures along the way. He was known all over Worcester County as "Crazy Bob," and no one paid any attention to these historic launches except for local people who said the blasts were causing the cows to stop giving milk and the chickens to stop laying eggs. It was not until July 17, 1929, when the 10th rocket lost its gas cap and exploded, that Goddard's activities attracted wider notice. The blast was felt for two miles, and the police, fire, ambulances, and reporters from Auburn and Worcester flocked to the spot expecting to find a plane crash. The resulting publicity and outcry by assorted state safety officials launched Goddard's career as the father of American rocketry. The launch site is in the National Register of Historic Places and is now located on the local golf course. This book covers Auburn from the first residents until 1960. It will hopefully bring back wonderful memories for former residents and let others know a bit about this community.

THE AUBURN HISTORICAL SOCIETY BOOK COMMITTEE MEMBERS:

Sari Bitticks, chair
Ryan Levesque
Helen Poirier
Renee and Earl Peace
Jack and Betty Murphy

Sonja Carr, cochair
Richard Steelman
Evelyn Bartlette
Richard Hedin
Claudette and William Morse

One

PEOPLE AND DWELLINGS

Many prominent Auburn people died long before photographs, but they are still remembered. Along with those mentioned in the introduction, Auburn can be proud of Jacob Whitman Bailey, son of the first pastor. He was a naturalist who was a famous scientist and improved the design of microscopes. He was a graduate of West Point and became a professor there in 1857. John Boyden was a lieutenant in the French and Indian War who lived on Pakachoag Hill about 1740. Peter Slater, who was at the Boston Massacre and participated in the Boston Tea Party, moved to Auburn in 1785 and ran a store in town for years. Ichabod Washburn was an apprentice in Auburn from 1816 to 1818. He went on to found Washburn & Moen Wire Co., later purchased by US Steel Corporation and named American Steel & Wire. Dr. Thomas Green settled in Ward and was town clerk in 1784 and 1785. He also served the area as a physician for 25 years. Once, he made six professional calls to the same patient and was paid 3¢, including the price of the medicine. There were several Dr. Greens after him. Dr. Daniel Green was one of the first abolitionists and an advocate of temperance. He died in 1861 at the age of 83. The Reverend Enoch Pond, DD, was pastor of the Congregational church. He augmented his salary by tutoring college preparatory students in his home. He edited *Murray's English Grammar*, which was used as a textbook in all the schools at the time. He also compiled at least 20 hymnals for use in church. Central Street, a county road and consequently one of the oldest areas in town, boasts several houses with rooms used for the Underground Railroad during the Civil War. One house, an inn belonging to F.E. Prentice, had a dungeon in the cellar for prisoners and may have been used during the Revolutionary War.

This Auburn High class of 1949 photograph shows Arthur Pappas at 17. He would later be head orthopedic surgeon at the University of Massachusetts and a professor at its medical school. He was the medical director and minority owner of the Boston Red Sox for 30 years. He and his wife, Dr. Martha Riley Pappas, have donated generously to the town.

Alex M. Pappas, brother of Arthur, served in the Navy. He and his crew were active in the Battle of Okinawa. He was elected or appointed selectman four times between 1959 and 1979. He also served on committees and was a representative to the town meeting. He owned the Pappas Building Company, Inc.

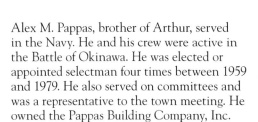

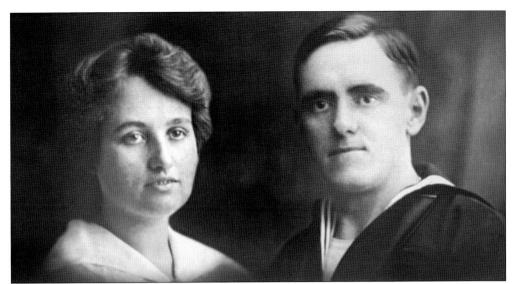

John Riley served in the Navy during World War I and held a variety of jobs. From 1922 to 1952, he was the town clerk of Auburn. His wife, Ethel, served as his assistant. They had the office of the clerk in their home on Southbridge Street.

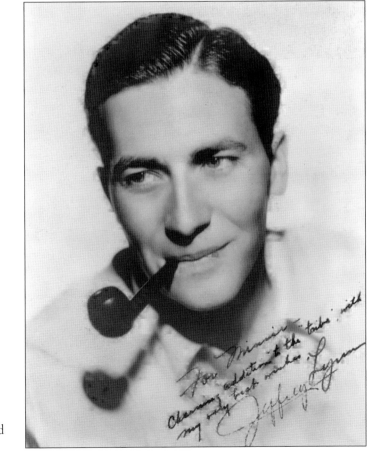

This is an autographed picture of Jeffery Lynn, Auburn's only movie star. Born Ragnar Lind, Jeffery was in numerous Hollywood movies in the 1930s and 1940s, including *Butterfield 8* and *The Fighting 69th*. When he left films, he transitioned to the stage and television. He died in 1995. The autograph is to his sister-in-law Minnie, who was married to his brother Iver.

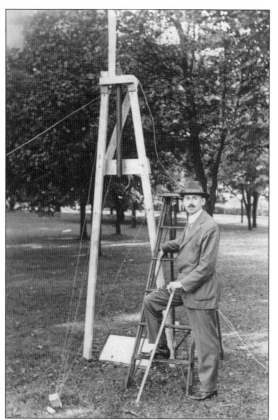

This photograph of Robert Goddard in front of ladder and rocket mount was taken by his wife, Esther, who was an accomplished photographer. She had schools named for him and, after going through his notes, got more than 130 patents based on his work. It is a documented fact that, without the work Esther Goddard put in, no one would ever have heard anything about Dr. Goddard after his death in 1945.

Esther Goddard is shown here at the dedication of the plaque commemorating several rocket launches by her husband, Robert, at Fort Devens, Massachusetts. Launches were moved there when the state fire marshal ordered Dr. Goddard to stop launching in Auburn after a rocket exploded dramatically in 1929. This memorial stone was moved and now stands outside the Auburn Historical Museum. (Courtesy of Raymond Twarowski.)

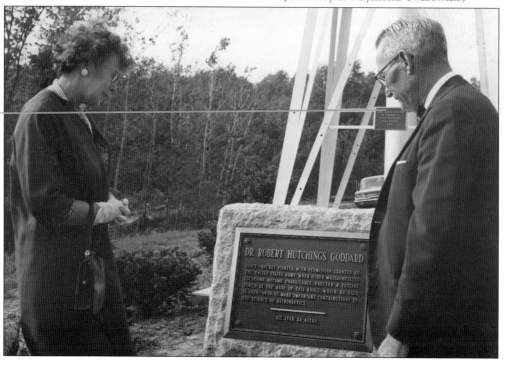

In 1909, the *Boston Post* newspaper made 700 identical ebony-and-gold canes to be presented to the oldest citizens of the towns the *Post* served. Over the years, many canes have been lost, and there are currently fewer than 40 original canes in existence. Most towns, including Auburn, now give replicas of the cane to their oldest citizens.

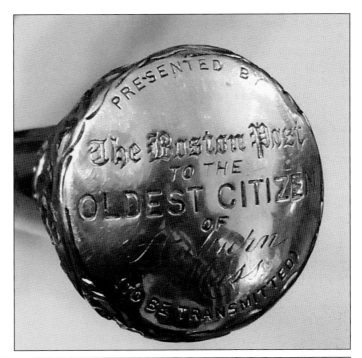

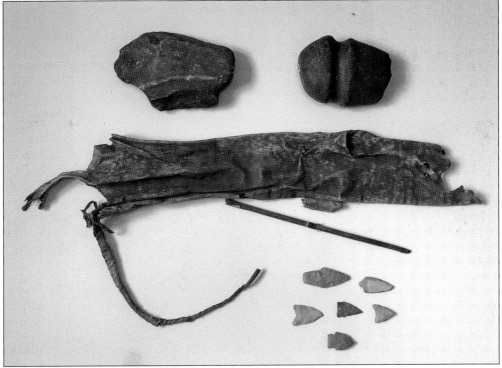

These are relics of the Nipmuck Indians who lived in the Auburn area. The quiver, which is reported to be 300 years old, was found wrapped in oiled paper inside a trunk in an attic. The ax head (top left) and club (top right) were found on Pakachoag Hill, as were the arrowheads. The arrow itself was with the quiver.

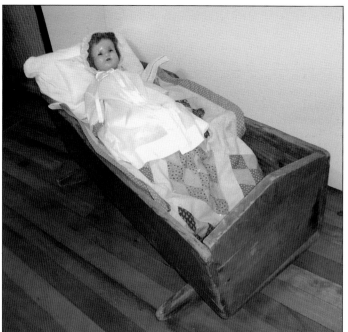

This cradle was used by the Howe family in 1870 for Arthur Howe and 1872 for Robert Howe. Aside from the mother's name, Anna, nothing else is known of the Howe family. The small quilt was made by Sonja Carr's paternal grandmother, Mable Van Norman Baker. The doll belonged to Sonja, who played with it in the 1940s. Her Swedish grandmother, Anna Carlson, made all the clothes for the doll and for Sonja.

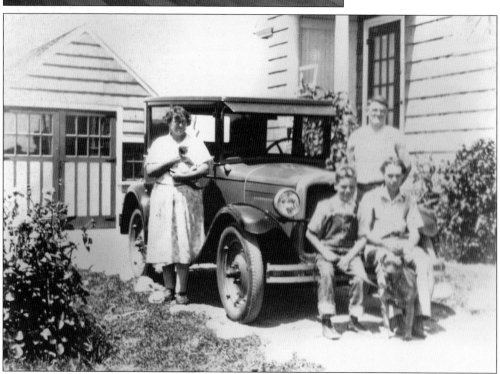

Sid (left) and Russell Mason (right) are sitting on the front of their family's new 1927 car with the family dog. Beside them is their father, Harry Mason, and to the left is mother Delia Mason, holding the family cat. The house, now at the corner of Route 20 and Appleton Road, was scheduled to be demolished for the building of Route 20. Harry Mason intervened, and the house was moved across the road. (Courtesy of Harry "Sid" Mason.)

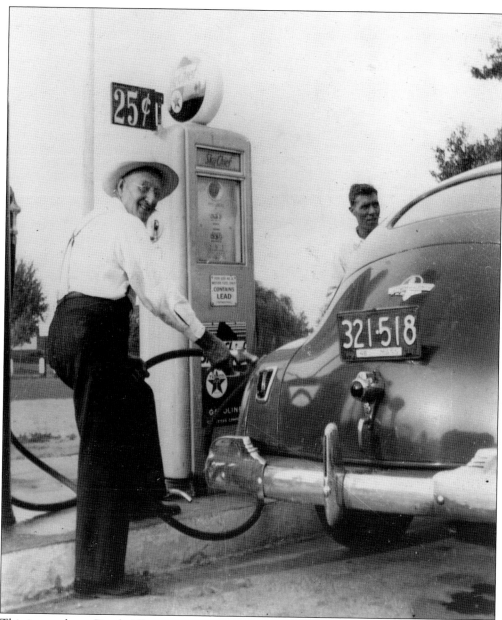

This image shows Frank Allen gassing up a car on October 13, 1948. Allen was one of Auburn's most prominent citizens. Born on the Gedraitis farm on Barnes Street in 1877, he served as selectman for 22 years and chairman of the board for 12 years. He was chief of police for seven years, inspector of slaughtering under the board of health for 28 years, and superintendent of stabling. He was state representative from the Auburn, Charlton, Leicester, and Oxford district for 12 years and a member of the Auburn Republican Committee for 20 years. He once participated in a milking contest between legislators, held on the Boston Common. Cows were brought in from each New England state, and the milkers were also from each of those states. Three state representatives from each state milked the cows from their own state. The prize was a battered cowbell and, of course, bragging rights. Representative Allen and his colleagues came in second, after Vermont. Frank Allen died in 1957 at the age of 80.

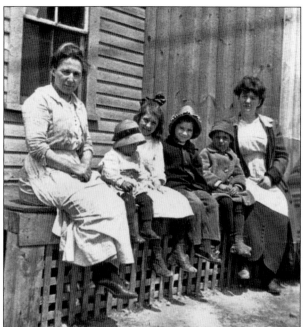

Pictured here are, from left to right, Sadie Bouley, unidentified, Blanche Bouley, unidentified, Ernest Bouley, and Blanche Mitchell. They are sitting on the porch of the family home on Albert Street in West Auburn. Blanche Mitchell was Sadie's sister, and the two unidentified children were Blanche's foster children. (Courtesy of Richard Hedin.)

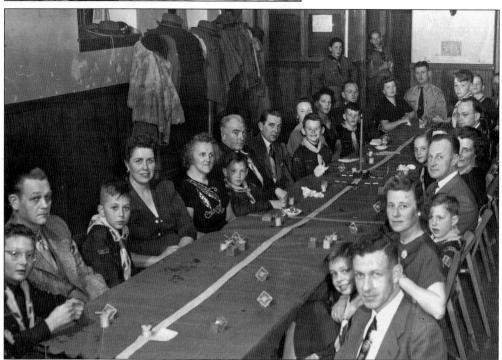

This is the Blue and Gold Cub Scout Banquet of 1949. Counterclockwise from the left are Kenny Long, Mr. Anderson, Bruce Anderson, Mrs. Anderson, Mary Bonzey, Ronald Bonzey, John Bonzey, Alan McCausland, Mr. McCausland, Mrs. McCausland, Eleanor Fuller, Richard Fuller, Freeman Fuller, unidentified, Richard Long, Mr. Long, Joel Prouty, Al Patrick, Mr. Patrick, Mrs. Patrick, Wayne Prouty, Mr. Ellsworth Prouty, Mrs. Valetka, Mr. Valetka, Charles Valetka, Kay Whittum, Alan Whittum, Gordon Whittum. (Courtesy of Ronald Bonzey, assisted by Richard Fuller.)

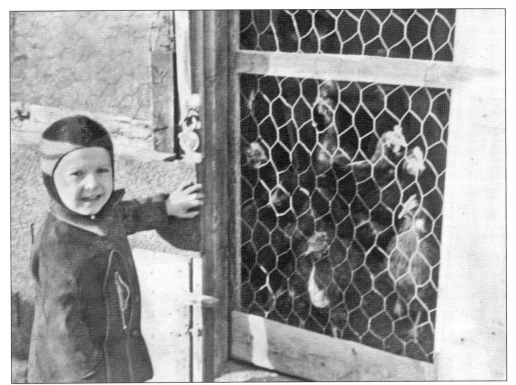

Richard Hedin, age 3, is pictured in 1941 looking at his grandfather's chickens. Albert Bouley raised over 500 chickens and sold the eggs in Worcester. A very generous man, he gave eggs and dressed chickens to family and friends. (Courtesy of Richard Hedin.)

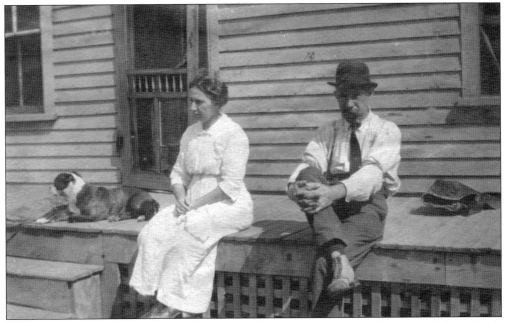

In this 1915 photograph, Sadie Bouley and brother Joe Lemire sit on the porch of their family house on Albert Street in West Auburn. (Courtesy of Richard Hedin.)

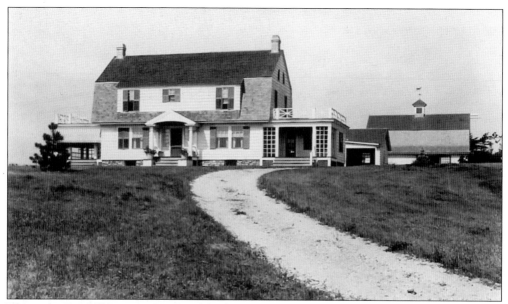

This is the Randall house at 790 Southbridge Street (where Crystal Caves is now). The Randalls raised gladioluses to sell at their own flower shop in Worcester. They also donated land for the Masonic temple and the Randall Street School. (Courtesy of Clifford Granger.)

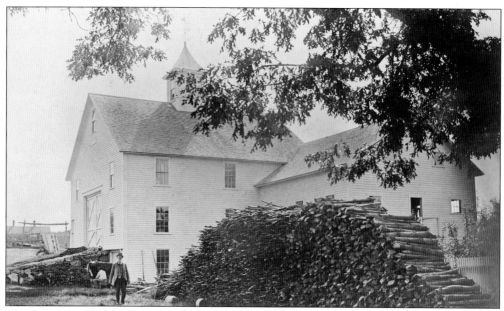

This house at 8 Maple Street in West Auburn was the home of Fred Chaney. Note the huge woodpile, which holds only part of the wood required to heat a home for a New England winter. Chaney had a wood business on Southbridge Street where the Auburn-Webster Lodge of Elks is now located.

This 1931 photograph is of Richard Warren and his sisters Marjorie (left) and Barbara in their home at 147 Central Street. Before entering the new Auburn High School, which was under construction, Richard had classes for a few months at the town hall. He graduated from high school in 1939 and entered the US Army Air Corps. After World War II, he lived and had his real estate business at 741 Southbridge Street.

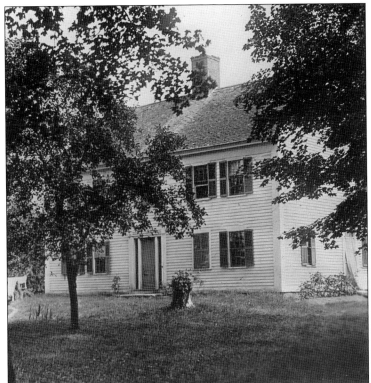

The Warren homestead was at 680 Southbridge Street on the southwest corner of Goulding Drive. It was built about 1780 by Jonah Goulding, who was active in Shays' Rebellion after serving in the Revolutionary War. There were 28 members of the Warren family born in this house, which was razed in the 1960s.

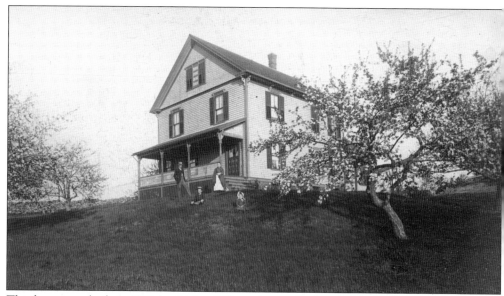

This home was built in 1893 by Richard Warren's grandfather Richard H. Warren. It was later owned and occupied by Richard's aunt Sarah C. Warren, then by Richard.

This house on Central Street was constructed in 1814 by Isaac Bailey. It was purchased in 1855 by Ebenezer and Clarissa Merriam, who lived there for 40 years until their deaths. Their children Leander and Lucy continued to live there, and in 1874 Leander began a butter and egg business from their house. He also used a cart to sell produce, which he raised at home.

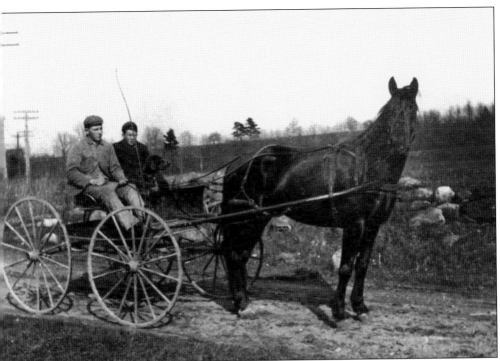

Harry Granger and Ralph Sibley are shown in a horse-drawn wagon, probably in the Prospect Street area. (Courtesy of Clifford Granger.)

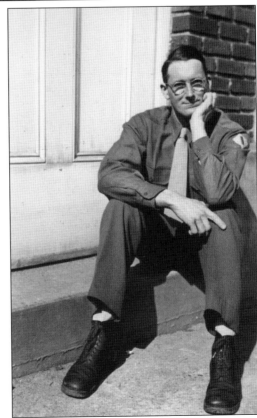

Homer Granger, brother of Clifford Granger, was born in 1913 and served in the US Army during World War II. He later became a mechanic at Cross & Bracci. (Courtesy of Clifford Granger.)

This is a 1918 photograph of Clifford Granger (left), mother Nora Granger, Homer Granger, and the family dog, Dick. The Granger family settled in Auburn at the end of the 19th century. Homer's and Clifford's father, Harry, was a farmer all his life. He had a dairy farm. Clifford, Homer, and Nora often assisted on the farm. Clifford still lives in Auburn. (Courtesy of Clifford Granger.)

This house, located on Auburn Street near Southbridge and across the street from Holstrom's Market, was built in 1831 using hand-hewn timbers fastened with wooden pegs. It was purchased by Andrew Holstrom in 1881 and became the family homestead. The building was razed in 1956 to make room for the Holstrom package store and a bank. (Courtesy of Kenneth Holstrom.)

When Fred Carpenter married Evelyn Searle in 1918, he owned a milk processing plant in Auburn and delivered milk with his truck. Carpenter also was Auburn's moth superintendent and cemetery worker as well as a town fire warden. He died in 1988 at the age of 95.

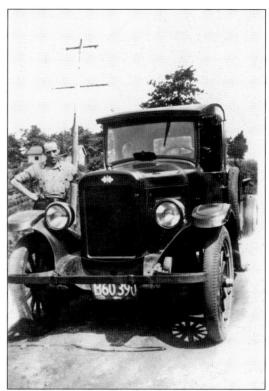

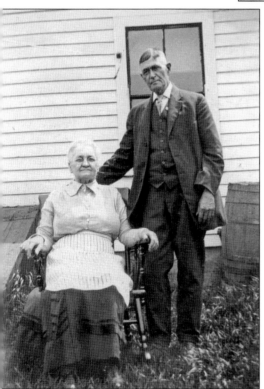

Joseph and Rosalie Champagne are pictured here. Many members of the Champagne family were involved in running Champagne's Market. (Courtesy of Kathy Champagne Herald.)

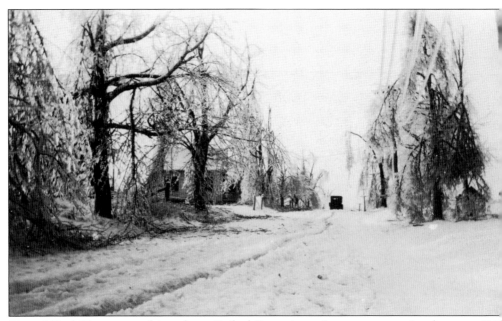

Here, Alfred Champagne drives down Oxford Street in an ice storm some time between 1918 and 1921.

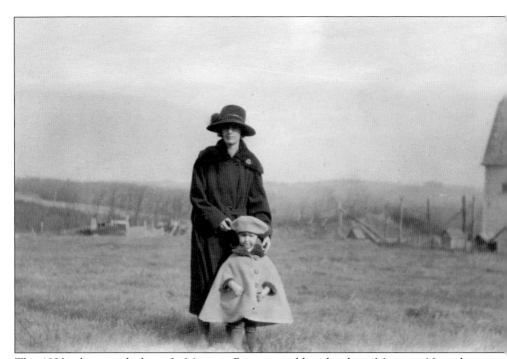

This 1920s photograph shows L. Marjorie Barrows and her daughter, Marjorie. Note the period clothing. Rockland Road is on the left.

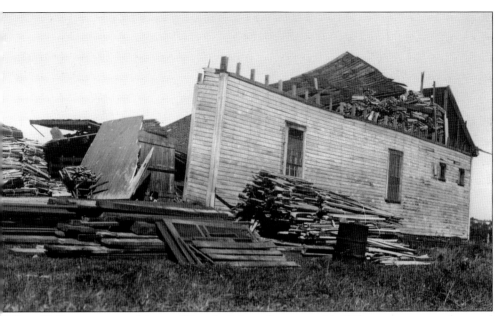

William E. Barrows notes this was "Grandpa's barn from east side." The structure was damaged in September 1938 by the huge hurricane that came through town.

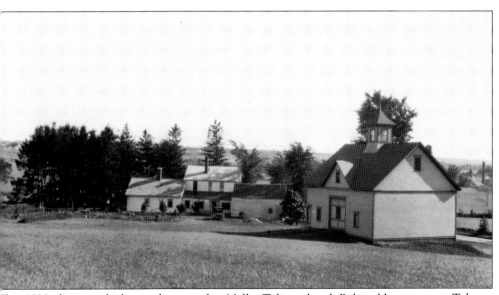

This 1920 photograph shows where teacher Nellie Tolman lived. Beloved by everyone, Tolman often invited students for picnics and took them on field trips. She was hired in 1913 by Julia Bancroft to teach at the Center School at a rate of $11 per week and later became the principal of the Julia Bancroft School. This property was the Sibley estate at the corner of Mill and Millbury Streets.

Siblings Bella and Raymond Twarowski are pictured before going swimming in Stoneville Pond. Note the trolley waiting station in the background. (Courtesy of Raymond Twarowski.)

Raymond and Doris Twarowski are pictured on their wedding day outside old St. Joseph's Church. Note the Stoneville School in the background. (Courtesy of Raymond Twarowski.)

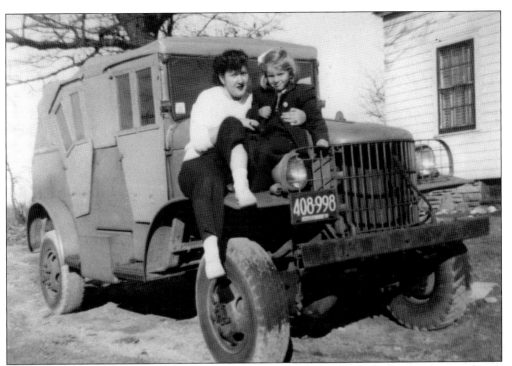

In this 1951 picture, Barbara Farley (left) and sister Gayle are seated on a retired Army vehicle owned by Harris Farley, their father. It was parked in their driveway at 4 June Street.

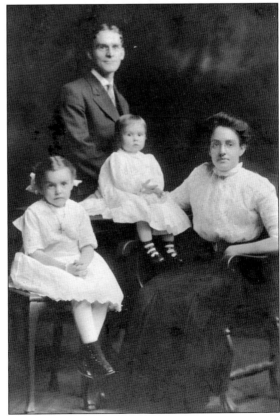

This is a family portrait of William and Eva Giles and their two children, Eva (left) and Hilga. They lived in a home at the corner of Route 20 and Elm Street. (Courtesy of David Rose.)

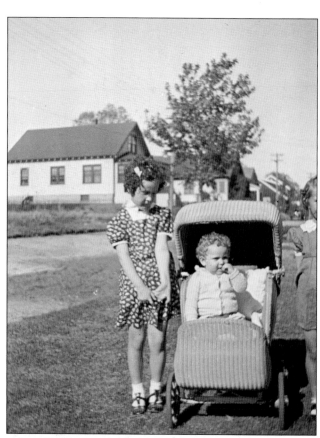

Barbara Farley, with Shirley Temple curls, stands beside Billy Bowes in the wicker carriage in front of 10 Robert Avenue. (Courtesy of Gayle Farley.)

The James Hilton homestead, referred to as the Elms, was built in 1825 at 38 Auburn Street. It is understood that a mortuary was under the house on the right-hand side.

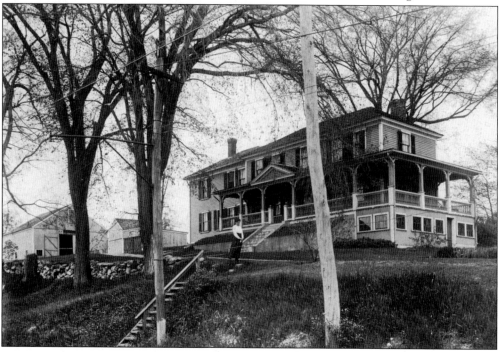

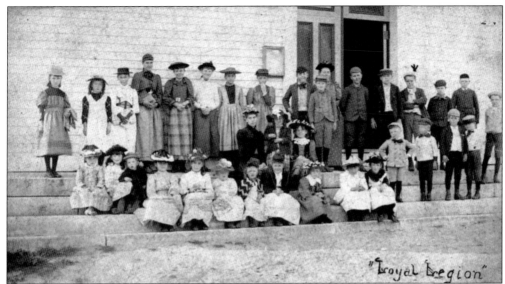

"Loyal Legion"

This unidentified but undeniably old photograph may be of a school group or family gathering. It is known that the third boy from the right on the top step is Arthur Howe and that the group called itself the "Loyal Legion."

Florence Mary LaPrade was about three years old when this picture was taken at the family homestead. She grew up to be a hunter, fisher, trapper, skeet shooter, and sportswoman. She died at the age of 89 in 2006. (Courtesy of David Rose.)

Pictured here are, from left to right, Roger Richer, Robert Johnson, Annette Richer, Stanley Johnson, and Harold Johnson Jr. in the backyard at 9 Howe Street in 1938. (Courtesy of Stanley Johnson.)

The children of Arthur Sibley are, from left to right, Laura Sibley, Bertha Sibley, Henry Sibley, Peris Sibley, and Aaron Sibley. (Courtesy of Clifford Granger.)

This house was Arthur LaPrade's home on Prospect Street in the late 1800s. It was said that Native Americans attacked the family living there prior to the LaPrades. Their name is lost to history. The house was fortified to protect the inhabitants from attack.

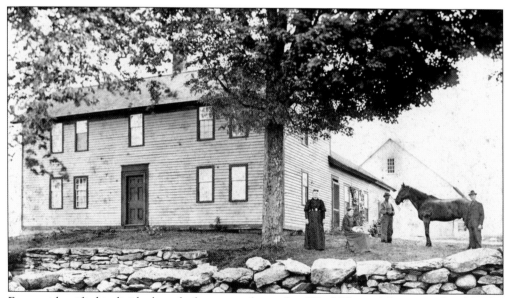

Four unidentified individuals and a horse stand outside of Fred Chaney's house on Southbridge Street in this early photograph. The Chaney family were among the first Baptists in Auburn in 1850. The Baptist church was on Southbridge Street near the West Auburn Cemetery. The church relocated to North Oxford in 1837.

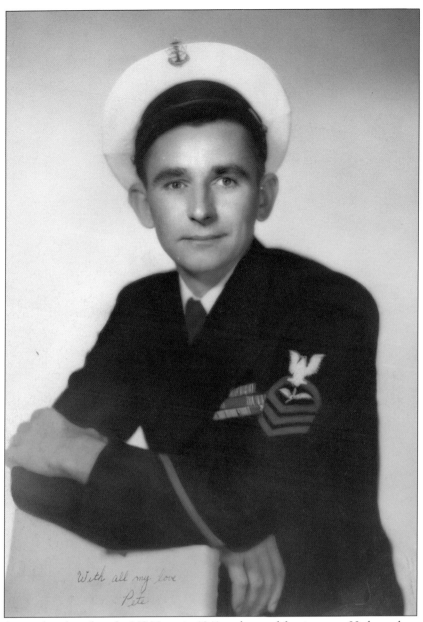

With all my love
Pete

Peter Askervitch enlisted in the US Navy in 1941 and served for six years. He logged more than 3,000 hours in the air. He was a member of the US Navy Pacific Fleet's VPB-28, a patrol bombing squadron, and his plane was a PBM flying boat. In 1944, Askervitch was an aviation machinist's mate, first class, to the VPB-28 squadron as the plane captain. He flew in the Pacific and was promoted to aviation chief machinist's mate. For his service and contributions, Pete received the Distinguished Flying Cross, the Air Medal with three gold stars, the American Defense Medal with the Fleet Clasp, the Asiatic Pacific Medal with one star, the Good Conduct Medal, the Victory Medal, the American Area Campaign Medal, and two Navy Unit Commendation Ribbons, one for service in VP-74 and one for service in VPB-28. He also received the Combat Aircrew Wings. He has lived in Auburn since 1924. After his military service, he worked as a mechanic for many years. He is an avid collector of military memorabilia.

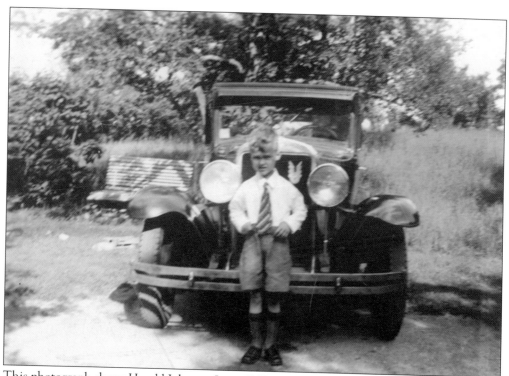

This photograph shows Harold Johnson Jr. in 1927 standing in front of the family car. As an adult, he worked for Johnson's Dairy and later worked in sanitation. He is known for always having an unlit cigar in his mouth. (Courtesy of Stanley Johnson.)

It is believed that Lucia M. Field was a teacher in the Auburn School System at the beginning of the 20th century. Her hat alone wins her a spot in this book.

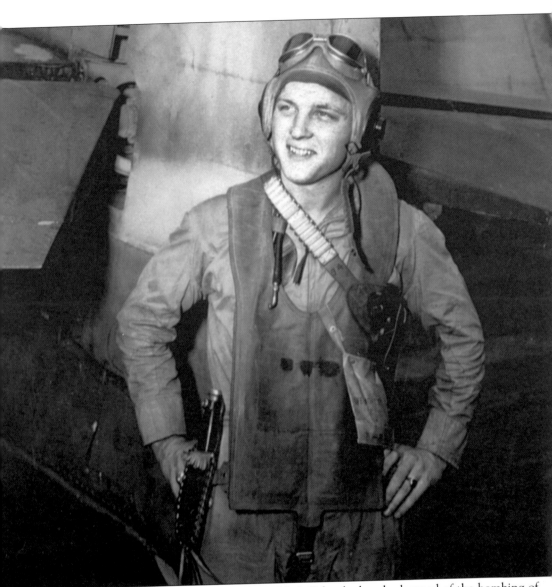

Raymond Twarowski walked out of Auburn High School when he learned of the bombing of Pearl Harbor. He joined the Navy at the age of 19. This photograph shows Ray at 21, just after the airplane he was the gunner for was shot down off the coast of Iwo Jima. He spent 18 hours in the water, including 9 spent holding up the badly injured pilot before he died. Raymond balanced a dye pack on his head for the whole time and dumped it in the water when he sighted American ships. He was rescued by a Navy convoy, and the Navy ordered him back to work in a plane the next day. After returning to Auburn, he married and became an insurance agent. For many years, he was the official Auburn town historian. Raymond still resides in Auburn. (Courtesy of Raymond Twarowski.)

Two

COMMERCE, FARMS, AND MILLS

The town existed on agriculture—especially dairy farming—and industry. The longest-lasting industry was Jonah Goulding's tannery near what is now Southbridge Street and Goulding Drive. The Stoneville Mill, completed in 1839, continued under various owners and survived several fires until it ceased business in the 1960s. While under the ownership of C.W. and J.E. Smith, it made cloth for Civil War uniforms. Charles Richardson had a sawmill in the early 1800s. Otis Pond bought it in 1812, and it became the Pondville fabric mill. Located on Mill Terrace, off what is now Route 20, it was destroyed by fire in 1952. The mills had many sporting events and rivalries. Other mills, such as Bonzey Sawmill, Hilton's Shoddy Mill, Chapin Brothers' Sawmill, and Dunn's Mill, provided jobs for many English and Irish settlers and sent goods to market all over the country. French Canadians came from the Quebec area to work in the mills, replacing the English and Irish workers who went off to the Civil War. Once the Irish returned from the war, they clashed with the French Canadians, and the two groups lived in different parts of town and did not associate with one another under any circumstances.

The Swedes came to Auburn in the 1870s and worked in the wire mills in Worcester. Another large industry in Auburn was the icehouses that preserved ice for local delivery. The Thomas Icehouse, built in 1930, was located on Pondville Pond and operated into the 1940s. Ice was cut, taken by conveyor belts into the icehouse, and preserved in straw and sawdust. It could be stored in these houses for up to two years. Johnson's Icehouse on Rochdale Street was active during the same period. Electric refrigerators, common after World War II, put the icehouses out of business.

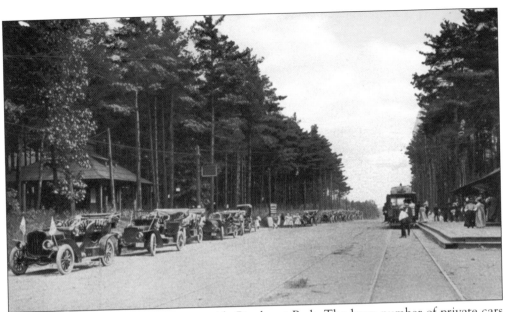

This photograph shows the street outside Pinehurst Park. The huge number of private cars foreshadows the end of the trolley system. The photograph was reportedly taken around 1903 on Pinehurst Avenue looking toward Auburn. The trolley waiting station is to the right, and the picnic grounds are to the left. Clearly, this was a very popular place to be.

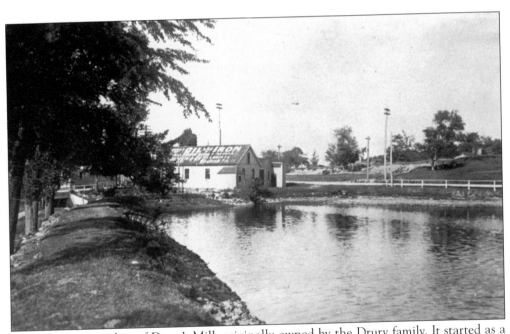

This is a distance shot of Dunn's Mill, originally owned by the Drury family. It started as a sawmill and was later retooled as a shoddy mill. Shoddy was a cheap fabric, often made of recycled materials. The photograph was taken in 1913. The body of water was once called Mirror Lake, then was renamed Auburn Pond. Originally, this was a wheat field, but it was flooded to create a mill pond.

This is Burnap Street at Southbridge Street after a storm in the 1950s. (Courtesy of Robert Johnson.)

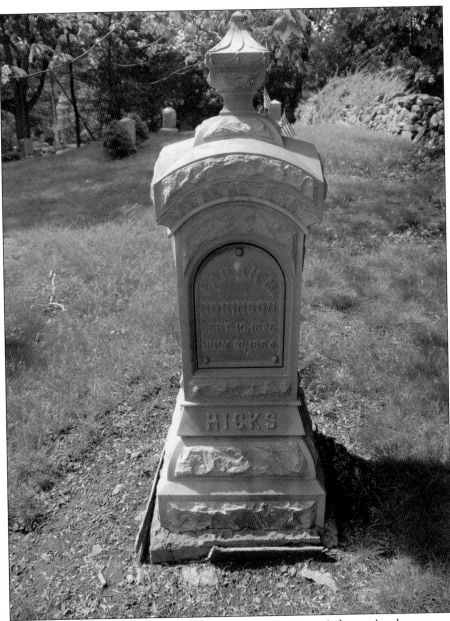

This zinc tombstone belonging to the Hicks family is unique in Auburn. A salesman came to Auburn in the early 1900s on horseback and managed to sell only one stone at a cost of $2. Many people felt the zinc markers were inferior, and they were therefore not favored in the area. The marker arrived in pieces and had to be assembled. The advantages, aside from price, were that the letters were raised and easier to read and there were detachable panels so names could be added very easily on all four sides. They were sold by the Monumental Bronze Company in Connecticut. It was the detachable side panels that made this grave marker popular for a time. This tombstone was used as a drop site during Prohibition; money was left inside, and the purchasers returned later on to pick up their liquor. Since zinc is now classified as a hazardous material, these markers are no longer available. They develop a specific patina from acid rain, and as the content of the rain varies from location to location, no marker looks exactly like another.

This photograph shows Herman Schunke's garage at the intersection of Oxford Street and Bryn Mawr Avenue. It was solely a car and pickup truck repair shop. (Courtesy of Stanley Johnson.)

Harlow's Dairy Bar in the Drury Square area was a restaurant and candy kitchen in the late 1940s and 1950s. Owned by Lester "Buster" Harlow, it was a popular place for Auburn High students to stop by after school for a soda. The candy was made on site, and the chocolate was memorable!

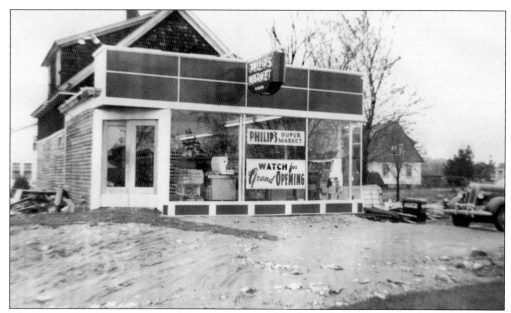

Charles and Paul Kotseas owned this popular neighborhood market in 1947. It was located in West Auburn. (Courtesy of Anthony Brooks.)

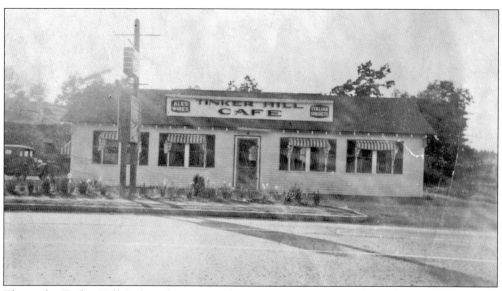

This is the Tinker Hill Café at the corner of Routes 12 and 20 on Tinker Hill Road. Built in the mid-1930s by Henry Camosse Sr., it was a barroom with music on the weekends. One popular group included James Mills with Harry "Sid" Mason playing guitar and Friedof Johnson on accordion. Later, it became part coffee shop and part residence for Lester Winkelmann, who owned the building around 1950.

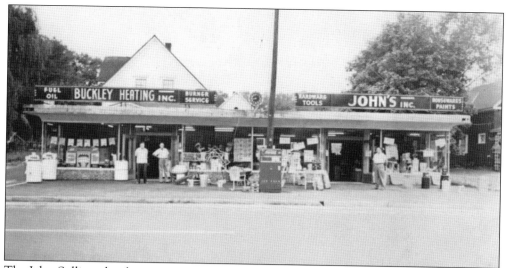

The John Sullivan hardware store stood at the corner of Southbridge and Howe Streets in the early 1950s. William Buckley, who owned the neighboring heating company, delivered oil and installed heating systems in the 1940s when he was an oil-burner repairman.

Frederic O'Shea built and ran the Mount Auburn Dairy in the 1930s. It was located on Route 20 in front of the Auburn airport, where Cabot's Furniture is now. O'Shea sold the dairy in the 1940s or early 1950s. He and his family lived upstairs over the dairy for a time, and he was also the sealer of weights and measures for Auburn. (Courtesy of Daniel O'Shea.)

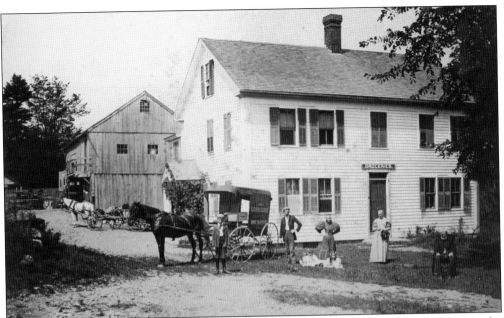

This photograph shows a medical delivery cart with the words "Corn Cure—Why Suffer?" on the side. It is stopped in front of a farm and grocery store located at 1 South Street.

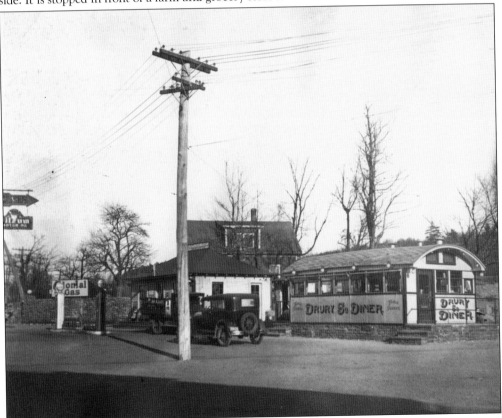

This photograph shows the southeast corner of Drury Square in 1930s.

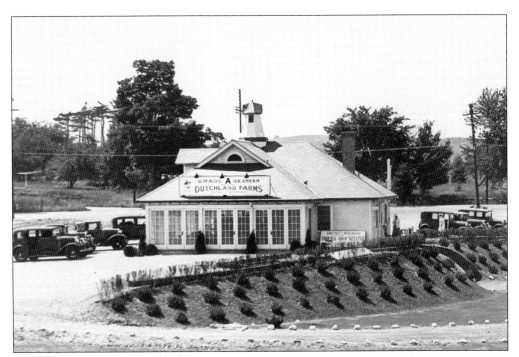

Dutchland Farms was located where Routes 12 and 20 merge going toward Oxford. It was owned by Dodd Inc. Proprietors and sold ice cream and sandwiches. It later became a motel and restaurants: China Terrace, Hawaii 12/-20, and presently Pub 99.

Georgie Stafford is shown shopping at Philip's Market, located at the corner of Appleton Road and Southbridge Street. One of the reasons she shopped there was because they delivered her groceries to her home. The market was owned by Paul and Charles Kotseas. (Courtesy of Anne Hansen.)

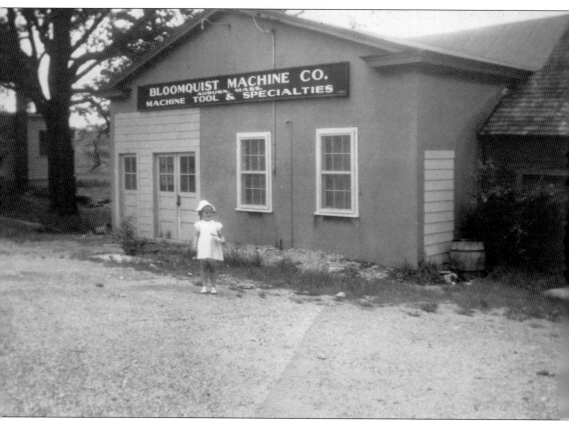

Eunice Bloomquist is shown standing before the Bloomquist Machine Tool Company, started by her father, Rudy Bloomquist, in 1941 in Oxford. In 1943, Rudy purchased a combination blacksmith shop/gas station at the corner of West and Southbridge Streets. The darker portion of the building on the right in the photograph is what is left of the 1700-era blacksmith shop. Dark Brook ran through the shop for "quenching the blacksmith's thirst" and other uses. World War II led to metal stamping and tool design. After the war, large figure-eight chain segments and file-drawer slides were made for companies as far away as Bridgeport, Connecticut. In 1950, the power company took the property for the construction of Dark Brook Reservoir. Rudy moved the business to Southbridge Street, where he consulted on designs and production of flight suit fasteners for the Apollo missions. The business closed in late 1960s when Rudy retired. His 1850 lathe was given to the Smithsonian. (Courtesy of Wayne Bloomquist.)

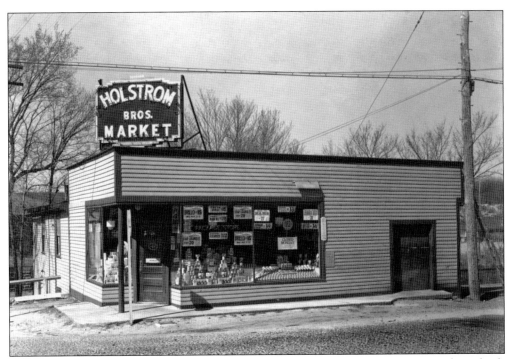

In the 1920s, Holstrom's Bros. Market was one of the first businesses in town to have both electricity and a telephone. It specialized in friendly, personal service, always selling local produce and freshly baked goods. During the worst of the Depression, Holstrom's extended credit to needy customers, and none of the bills ever went unpaid. The market, which had limited parking, closed in 1966 with the advent of supermarkets. The store was used for several other businesses until it was demolished in 2004. A boulder with a plaque now marks the site of this Auburn landmark. Shown below is the business's 1940 Dodge pickup truck. A special treat for the Holstrom children was a Sunday ride in the truck, which has been lovingly restored and is often seen around Auburn today at civic events. (Both, courtesy of Kenneth Holstrom.)

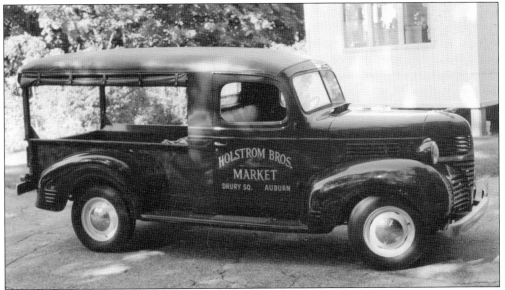

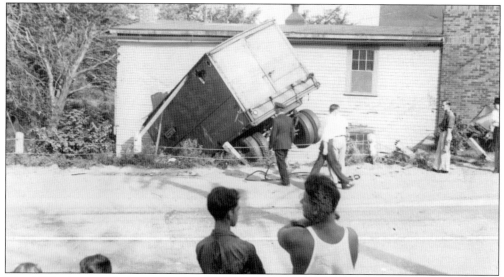

This 1950s photograph shows a trailer truck that crashed into the back end of Holstrom's Market. The driver perished in the accident. It is not known why he went off the road. (Courtesy of Stanley Johnson.)

This Esso station on Route 12 was owned by Vaughn MacKay. It opened in 1949. MacKay was later in partnership with his son Eugene. Besides selling gas, the station did mechanical repairs. It was always a pleasure for them to serve the people of Auburn. (Courtesy of Eugene MacKay.)

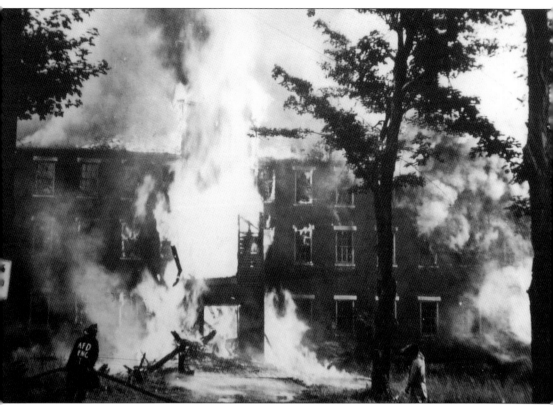

This is a view of the spectacular Pondville Mill fire, which is covered in more depth later in this chapter. According to one story that was retold by people watching the fire, around World War I, a man came to the mill intent on murdering his ladylove who worked there. He shot at her and missed, hitting a man named Reithal, who perished on the spot. The killer fled, and the state police were called. At this time, the state police did not carry weapons, so they went to the Burgess family home to borrow a shotgun (the Burgess family owned the land the mill was on). Armed with the borrowed weapon, the police trailed the man to Leicester, where he was arrested. (Courtesy of Raymond Twarowski.)

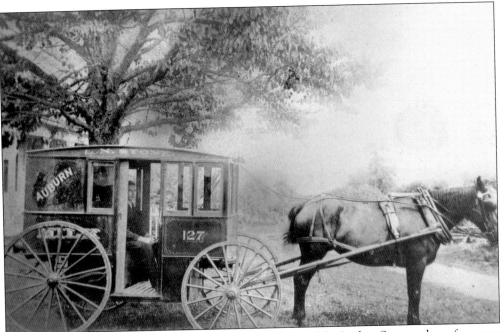

Herbert N. Anderson is shown driving the milk cart owned by Luther Stone, whose farm was located on Stone Street. That farmhouse still stands and is in the National Register of Historic Places. This photograph is from the late 1800s. (Courtesy of Raymond Twarowski.)

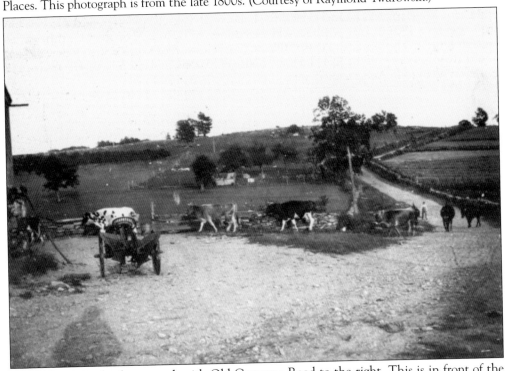

Mill Street is in the foreground, with Old Common Road to the right. This is in front of the Burgess dairy farm before the construction of Route 20. During construction, three tunnels were built under the road to allow the cows to go across and forage. (Courtesy of Lois Burgess Alger.)

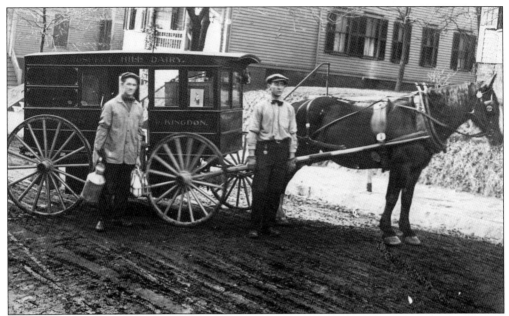

Above is Kingdon Dairy's 1908 delivery wagon. The dairy delivered almost 500 quarts of milk per day; note the delivery is made in cans, with the milk being poured into the customer's own receptacle. The photograph below shows the milk room behind the country wagon for picking up milk in 1909. The wagon shows the insignia of Kingdon Dairy as well as a partner, Prospect Hill Dairy. Kingdon's was located behind the house at 56 Pakachoag Street. Fred Kingdon was the owner from 1908 to 1931, when he sold the business to H.P. Hood & Sons. He then started another dairy, which was sold in 1958 to Hillcrest Dairy Farms. Fred Kingdon was a former Auburn selectman, past master of the Joel H. Prouty Lodge of Masons, and much more. He was born in England and lived in Auburn for 77 years.

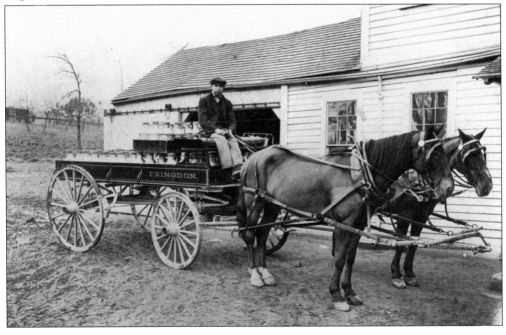

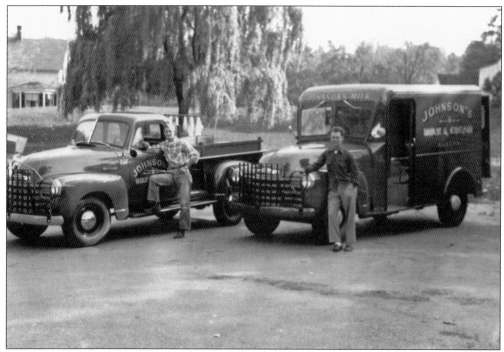

Harold E. Johnson and his wife, Violet, started a milk delivery business in 1935 out of their home at 9 Howe Street. At first, Harold would deliver milk during the night because people in those days had iceboxes, and the blocks of ice did not melt as quickly. After the war, milk deliveries were during the daytime. Over the years, the business increased to two trucks with every-other-day deliveries to four milk routes in Auburn. Expanding to Worcester and other neighboring towns, Johnson added other dairy products, such as eggs, butter, and orange juice. The Divco truck below, manufactured in the 1940s, was used on the delivery routes.

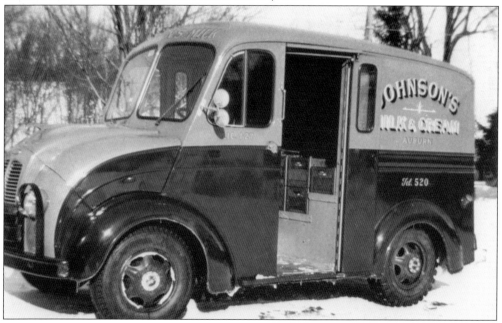

Harold and Violet Johnson, pictured above, started Johnson's Dairy in 1935 out of their home. They were in business until 1978. Harold, a lifelong resident of Auburn, died in 2001 at the age of 95. Violet passed away in 1996 at the age of 86. (Courtesy of Stanley Johnson.)

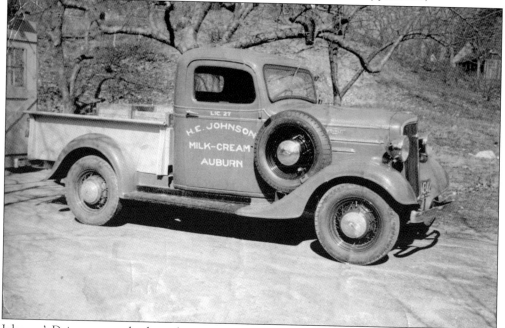

Johnson's Dairy was proud to have this 1929 Model A pickup truck for its early deliveries. Eventually, the business expanded to include two delivery trucks, and rounds were made every other day on four milk routes in Auburn.

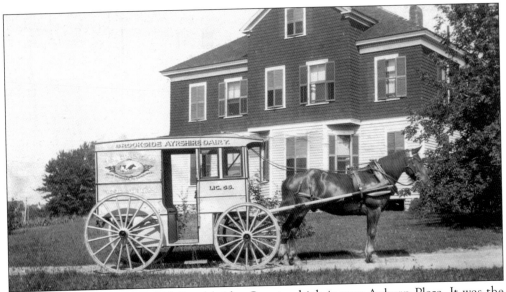

This house was located at 705 Southbridge Street, which is now Auburn Plaza. It was the Brookside Ayreshire Dairy, and the wagon pictured is the delivery vehicle. (Courtesy of Clifford Granger.)

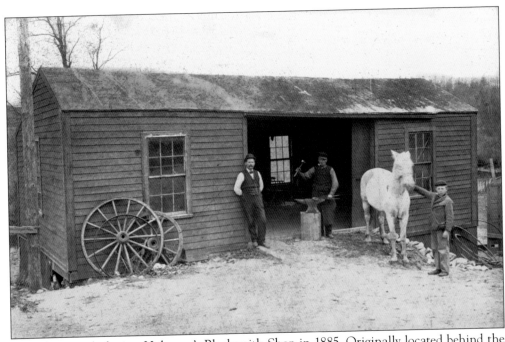

This photograph depicts Holstrom's Blacksmith Shop in 1885. Originally located behind the Holstroms' house, the shop was moved in 1885 to land purchased at the northwest corner of Drury Square, opposite Dunn's Shoddy Mill. (Courtesy of Kenneth Holstrom.)

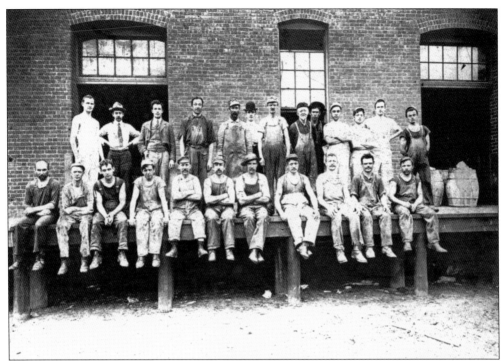

This photograph shows the workers of the Worcester Rendering Plant on Southbridge Street. This business dealt for many years with reducing large animals to their component parts. The effluvia from the animals was dumped into Dunn's Brook, leading to many derogatory nicknames for the waterway, most best left to the imagination.

This well has been on Central Street since the beginning of the town. It is the only known well never to switch over to a pump, having always used a pail on a rope wound up on a drum. At one point, the house it belongs to was owned by Daniel Love, who had a hatchery. People could bring eggs to be hatched in his incubators.

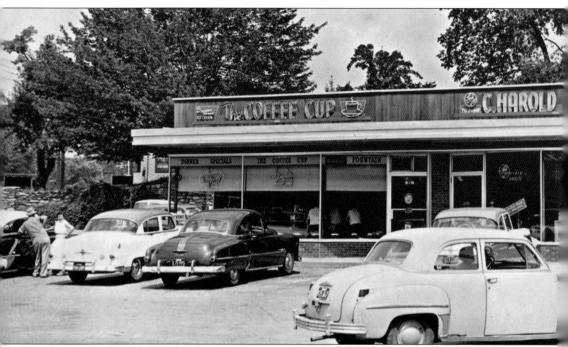

This panoramic view is of the shops at Drury Square in the mid-1950s. The buildings were constructed by the Cross Brothers. They are, from left to right, Brownie Taylor's restaurant, the Coffee Cup; Harold McGraw's appliance store; Walk-Rite Sundial Shoes, owned by Philip Lutfy; and Blum's Drugstore, owned by Win Blum. Located about half a mile from the center of town, Drury Square has always been the center of commerce. Feed and grain stores, assorted shops, the fire department, the train station, and the post office made this the heart of the Auburn business

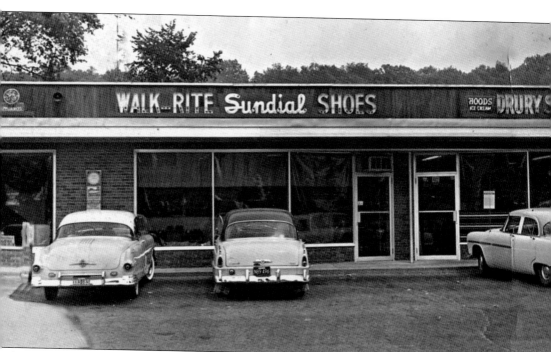

district. Drury Square was built on land owned originally by Thomas Drury in the 1700s. The Drury family owned 250 acres in town and had several mills, and Thomas ran the first tavern and stagecoach stop, Drury Tavern, located in the center of town. The first church services were held in the tavern, and Thomas also donated the land for the first meetinghouse. (Courtesy of Robert Haroian.)

The Oxford Grain Store on Auburn Street was run by Walter Merriam Sr. in the 1920s and 1930s. Early on, only a small area on the left was heated. The store was owned by Charles W. King in the late 1940s and 1950s and by Edward Dickinson after 1957.

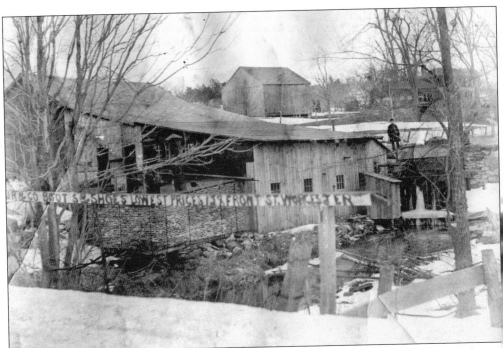

The pre-1900 Dunn's Mill at Drury Square, located on the present site of Goddard Park, was originally a sawmill and later a shoddy mill.

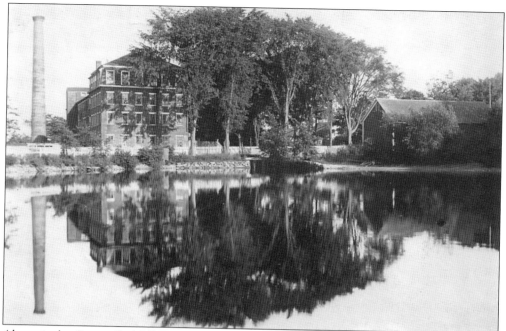

Above is the Stoneville Mill, known also as the Queensbury Mill and Smith's Mill, on Main Street. The Jackson Club, a social organization for mill workers, is at the right, and Oxford Street is on the left. In 1799, Jeremy Stone bought 250 acres to build a mill, completed in 1835. He went to Georgia on business, contracted malaria, and died in 1839. The mill had several owners and did poorly until the Smith brothers made a success of it. They provided cloth for Union soldiers' uniforms in the Civil War. After the last Smith brother died in 1880, the mill was closed. It was then purchased by William Hogg and ran, despite many fires, until a final fire in 1974. The ruins are clearly visible from Main Street. Below is a 1940 view of the Stoneville Mill when it was owned by the Hogg family.

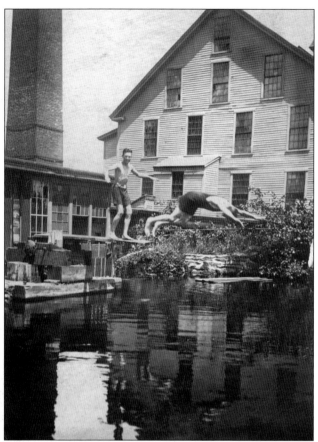

This photograph, taken on June 30, 1925, shows brothers David P. Doherty II (left) and Philip Doherty (right) swimming outside of the Pondville Mill. The pond was created by the dam used to create waterpower for the mill. Though the mill is long gone, the dam and pond remain.

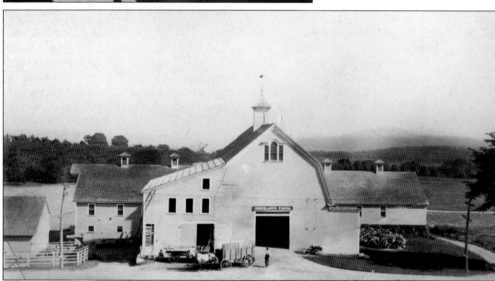

Owned by Frank P. Knowles in the 1930s, this dairy farm also boasted a quarter-mile horse track to exercise Knowles's trotters. The farm covered 132 acres with a windmill that raised water from the well. In his will, Knowles left money to expand the Pakachoag Church and, ultimately, build the new church. The farmhouse and one log-cabin outbuilding still stand.

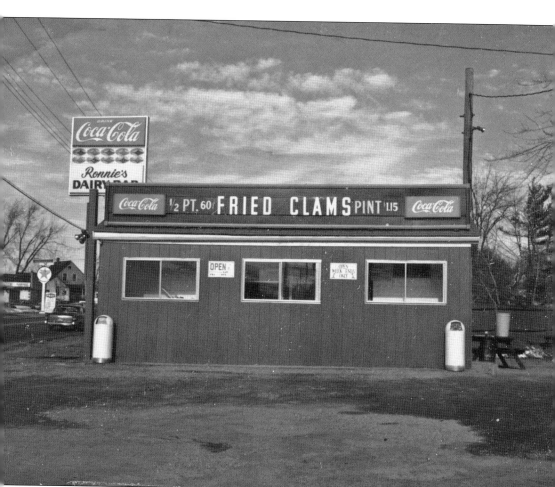

Edmund and Florence Lemansky founded Ronnie's in Oxford and moved it to its current location in 1957. Originally, the building was 12 by 24 feet in size. For several years, the Lemanskys had to prepare the food in the kitchen of a house they owned next door. They sold fish only on Friday but quickly realized how popular fish was. Soon, Ronnie's became the place in Worcester County to go for clams. When business was slow, they used to play basketball. The hoop was located where the ice-cream shop is now. Ronnie's was always a family-run business, and it remains so to this day. Edmund Lemansky was a parks commissioner for 35 years, and Lemansky Park was named in his honor.

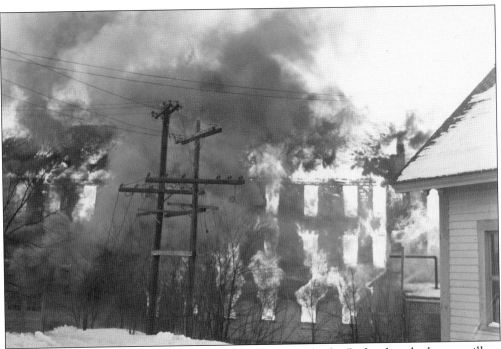

This is the Pondville Mill on Mill and Millbury Streets. Charles Richardson had a sawmill on the site in 1790. A gristmill was built next to it, then a fabric mill. Eventually, the Pond family purchased the site and became very successful. In 1878, a shoddy mill was added. Shoddy was a cheap but sturdy fabric made from rags and scraps. The mill suffered a fire in 1865 but was back in operation six months later. There was another fire in the 1870s as well as a third in 1880, and the mill was rebuilt. After several changes in ownership, business fell off. The owners were removing the machinery when the building was destroyed by a fire of "mysterious origin." The photograph below shows the dramatic fire that destroyed the Pondville Mill in the 1940s. The pond and dam remain today, but all traces of the mill itself are gone.

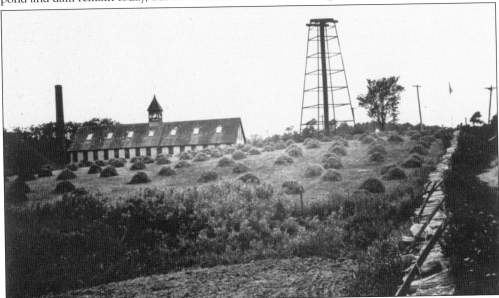

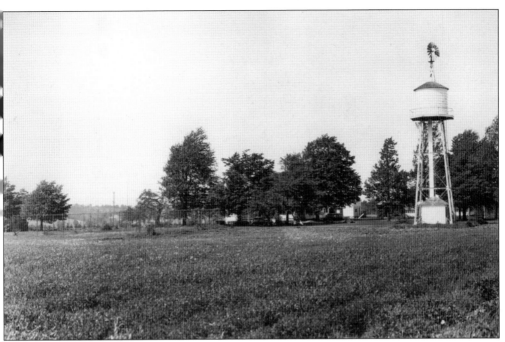

In 1797, the Stoddard family established Hamnergerill Farm. This was a general-purpose farm, and they had activities such as Camp Fire Girls. There were cottages there for a camp for many years. In 1934, the Cutting family purchased the property, and they passed the farm on to their daughter Sylvia, who renamed it Hillcrest Farm. Sylvia married Donald Post and changed the farm into a garden center known as the Farmer's Daughter. They also raise beef cattle. Workers' housing and the water tower are visible in the photograph above. Below is a 1935 photograph of an old wood-constructed silo at Hillcrest Farm, which burned down in 1947. The barn was replaced with a new barn and a ceramic silo. (Both, courtesy of Donald Post.)

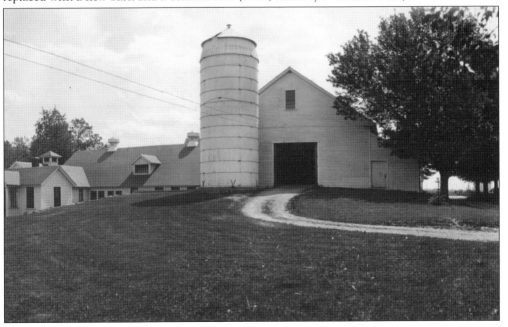

In this 1937 photograph of Hillcrest Farm, owned by Adna Cutting, a storage barn can be seen on the far left with a team of horses lead by Howard Pease, the farm manager. The dollhouse, in the middle of the sheds, was built out of piano crates for Adna and Grace's daughter, Sylvia, as a playhouse. The dollhouse survived the 1947 fire and is still on the property. Hillcrest was a large producer of milk and hosted the New England Dairymen's Field Day. Farmers got together to exchange new ideas in farming. There were also tractor and oxen pulls, 4-H displays and other family friendly activities. (Both, courtesy of Donald Post.)

Three

CHURCHES

The first church in town was the Congregational church, established in 1776. Settlers first met in Drury Tavern before building a church/meetinghouse. The first town hall was in the basement of the meetinghouse, which burned in 1896, was rebuilt in 1897, and stands today, having been added to and renovated many times.

The Baptist church was founded in 1815 by Jonah Goulding and remained in Auburn until 1837. In 1867, the first official Roman Catholic mass was said in town on Main Street. However, it is very likely that mass had previously been said for the Catholic residents of the area who began arriving in 1842 as Fr. James Fitton, a priest who had traveled western Massachusetts in 1834 from his base in Millbury, had been assigned to say mass in Worcester once each month and converted some residents to Catholicism. In 1869, St. Joseph's Church was built on North Oxford Street. Because of the rivalries between the Irish and the French Canadians, two doors were built, one for each group. Even the choir loft was divided. The New St. Joseph's Church was built on North Oxford Street in 1950, across from the old church.

The Episcopalians arrived in Auburn in 1906 with St. George's Mission. They formed a recognized church, St. Thomas, in 1933. The Lutherans came in 1920. In 1929, Pakachoag Chapel, a Congregational church, was founded. In 1952, a second Roman Catholic church, North American Martyrs, was built off of Pakachoag Street on Wyoma Drive. *Wyoma* is the Mohawk word for the fairest maiden of the tribe and is used by Christian Indians to indicate Mary.

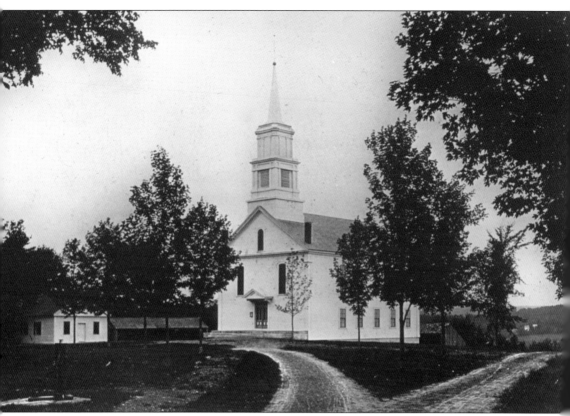

The First House of Worship was built in 1773. It was without a belfry or steeple. The first minister was the Reverend Isaac Bayley. In 1838, the church was moved back from the center of the common, turned around, and made 10 feet longer; a steeple was also added. The town hall was in the basement of church. In 1789, the four front seats in the front gallery were reserved for the choir, and in 1831, $25 was allocated to provide for church singers. This church was totally destroyed by an accidental fire on February 4, 1896. Capt. C.A.Q. Norton was preparing a Grand Army of the Republic lecture and was gilding a large framed picture of the Battle of Gettysburg. He stepped on a match and knocked over a can of paint thinner, which ignited a large American flag. He was badly burned, and the church was destroyed. An excellent example of the spirit found in Auburn is that no one blamed him for the fire.

Early foot warmers were ceramic and filled with boiling water. Later, they were made of ornate tin. These were not affordable by most people, so the wooden-frame warmers, shown right, were developed. A tin box with a tin ember tray was very commonly used in the 1600s. This foot warmer was used by the Stone family in Auburn at the First Congregational Church from 1784 until 1896, when the church was heated.

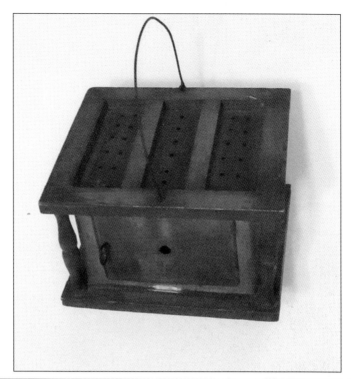

After the destruction of the First House of Worship, a new church was built, with a cornerstone laid on September 26, 1896. The church was dedicated on March 2, 1897, and the bell was placed in the tower on June 4, 1897. On Easter Sunday, 1913, electric lights were first used in the church. In 1925, the vestry was remodeled, a new kitchen was built, and a modern heating plant was installed.

In 1867, mass was said for the first time in Stoneville. In 1869, a church was built as a mission of St. Peter's Church of Worcester. It was named St. Joseph's and consecrated in 1869. In 1907, St. Joseph's became a parish.

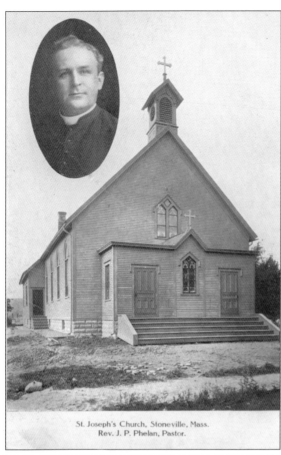

St. Joseph's Church, Stoneville, Mass.
Rev. J. P. Phelan, Pastor.

After over 40 years of use, the little mission church built in 1869 was no longer adequate for the growing congregation, and a new church was built and dedicated on October 12, 1950.

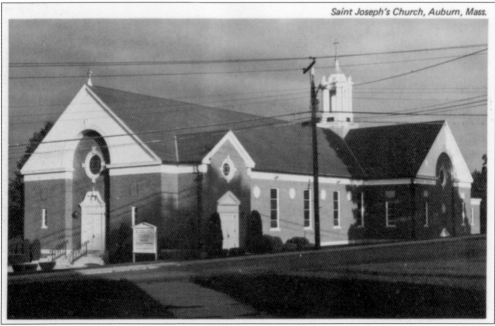

Saint Joseph's Church, Auburn, Mass.

During World War II there was a Boys' Brigade at St. Joseph's Church. It was similar to Scouting. Pictured here are Robert (left) and Richard Murray. (Courtesy of Robert Murray.)

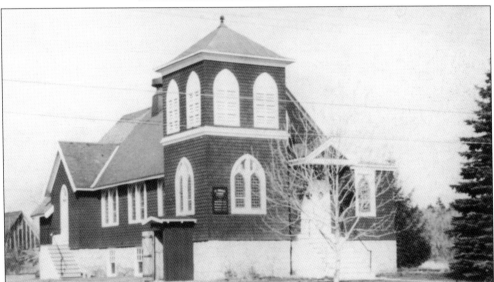

The first meeting of Episcopalians was held about 1906 in a house on Main Street. Called St. George's Mission, the congregation outgrew this space by 1928. They purchased an empty church from Cherry Valley, moved it to Auburn Street, and kept the old name of St. Thomas. With the construction of Route 290, the church was dismantled, and a new church was built in its present location on School Street.

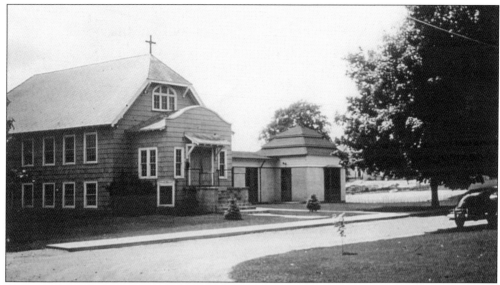

Shown here is the original Bethel Lutheran Church with the new parish hall at the corner of Homestead and Bryn Mawr Avenues. The hall was dedicated on March 5, 1950. (Courtesy of Bethel Lutheran Church.)

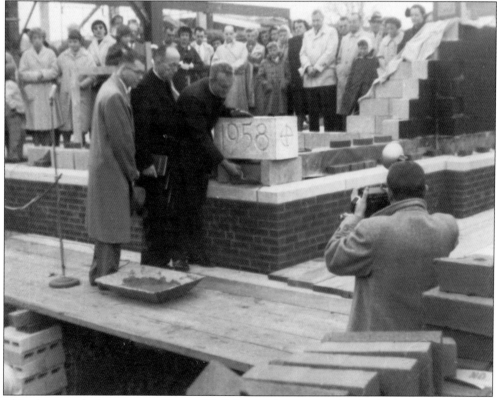

This photograph shows pastor George W. Schwanenberg cementing in the cornerstone for the current Bethel Lutheran Church on November 2, 1958. The new church was dedicated on August 2, 1959. (Courtesy of Bethel Lutheran Church.)

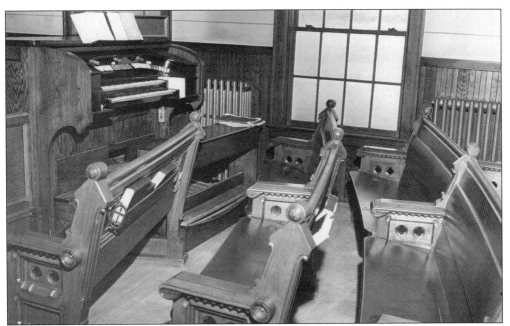

This is the interior of the original Bethel Lutheran Church, which was completed in 1929. (Courtesy of Bethel Lutheran Church.)

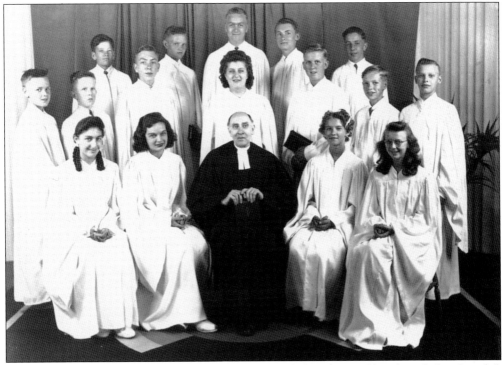

This photograph of the 1944 confirmation class at Bethel Lutheran Church includes, from left to right, (first row) Margaret Soojain, unidentified, Pastor Carlson, and two unidentified girls; (second row) Charlie Olson, four unidentified individuals, Robert Nelson, and David Hulgren; (third row) unidentified, Eric Bylund, Kenneth Lundell, unidentified, and Richard Steelman.

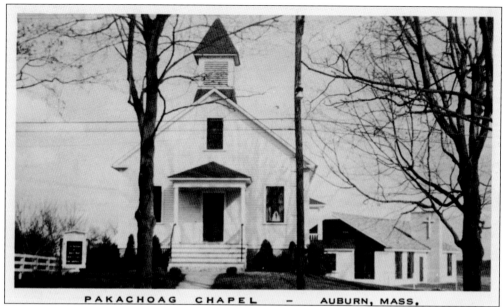

PAKACHOAG CHAPEL — AUBURN, MASS.

On Sunday, June 23, 1924, a group of 18 people gathered at Pakachoag School for the first service of this United Church of Christ congregation. They met there until it was destroyed by fire on June 7, 1934. Using insurance money, a loan from the City Missionary Society, and contributions, the modern church pictured above was built in five months and held its first service in November 1934.

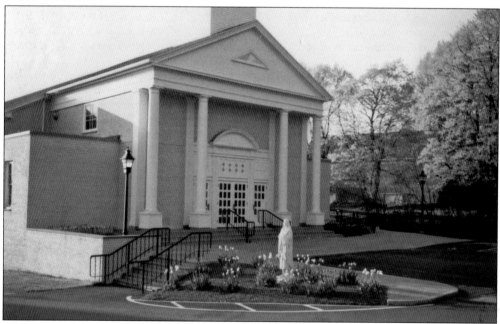

The parish of the North American Martyrs was founded in 1952. Located near the Nipmuck Village, it was named for the eight Jesuit missionaries who first preached to the Native Americans. The Mohawks used the name Wyoma, meaning "the most outstanding girl in the tribe," to indicate Mary, and the church's address, 8 Wyoma Drive, reflects the history behind the naming of the parish.

Four

SCHOOLS

One of the first activities that engaged the earliest residents of the town of Ward (later to become Auburn) was the planning of a school system. The memberships of the first school committees clearly reflected the importance assigned to this task in that the town's founding fathers, whose names are preserved on present-day town sites, agreed to serve: Andrew Crowl (Crowl Hill), Lt. Thomas Drury (Drury Square), and Levi Eddy (Eddy Pond). The original school system was comprised of six "squadrons," or districts, each named after the section of the town from which it drew students.

The school year was divided into two terms—a 10-week summer term that began on the first Monday in May, and a 12-week winter term that began on the Monday after Thanksgiving. The teacher for the winter term was a male, while the teacher for the summer term was female. In 1868, when the district's budget was increased from $595.43 to $1,383.56, a third term was added, and the year was reconfigured to an 8-week summer term, a 9-week fall term, and a 12-week winter term. The length and timing of the three terms clearly reflects the strongly agricultural nature of the town.

"Spelling schools" were held during evenings throughout the year for young and old. Several citizens of the town even established academies in their homes or at a church to provide "higher education" to the populace—and not just the children. Some of these progressive teachers, who taught subjects such as Latin and English literature, were local residents from such schools as Mount Holyoke Seminary and Yale College.

Enrollment increased from 278 in 1851 to 1,230 by 1930. Accordingly, the district's budget was increased to provide much-needed amenities: a school nurse, a hot-lunch program, a practical arts department to teach manual skills, and a domestic arts department to teach cooking and sewing. The system was increased by five schools between 1924 and 1930. Auburn had no high school until 1935, so all students had to commute to Worcester by train or trolley.

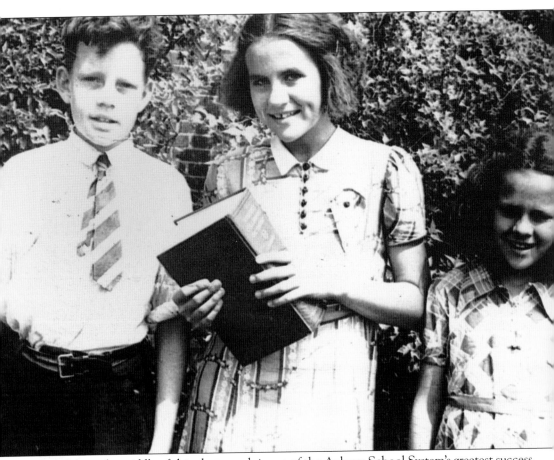

Standing in the middle of this photograph is one of the Auburn School System's greatest success stories, Elizabeth Ann Rice, who, after winning many local spelling bees, won the National Spelling Bee in 1939. She won in the 58th round on the word "thesaurus." Her sponsor was the *Worcester Telegram & Gazette* newspaper. Since the spelling bee began in 1925, Elizabeth remains the only winner from Massachusetts. She was welcomed home by a parade and over 5,000 Auburn citizens. She married James Riza and had seven children, and in later years, she became a marathon runner and competed in the Boston Marathon three times. She worked as an office manager for over 30 years and was a dedicated community volunteer. She died in 2012 at the age of 85.

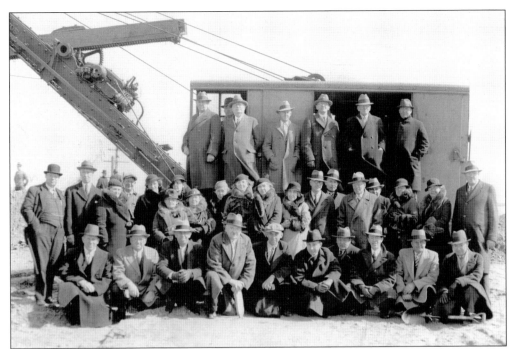

This photograph shows the ground-breaking ceremony for the Auburn High School in 1933. The school was completed in 1935. Shown are selectmen and various visiting dignitaries.

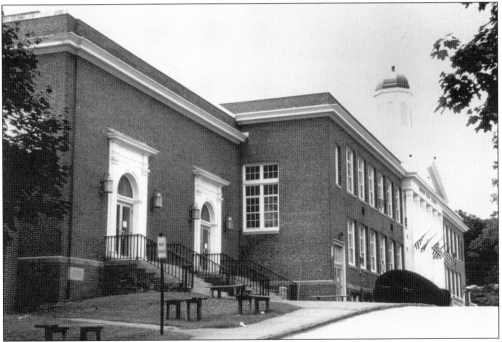

Due to the increasing cost of tuition and transportation of pupils to Worcester, a new high school was built in 1935. It had the capacity for 400 students and was fully equipped with the most modern facilities, including laboratories, a library, a manual training room, and a kitchen. The auditorium and gymnasium could seat 600. The school was formally dedicated on January 16, 1936.

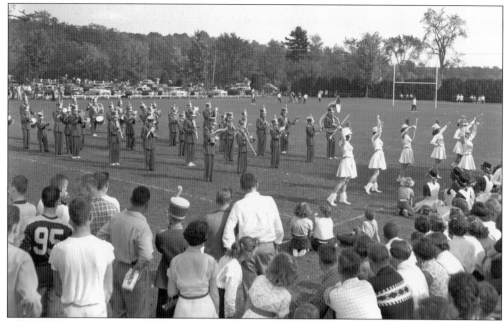

The Auburn High School Band and the majorettes give a halftime performance on the Auburn Athletic Field during a game in the 1950s.

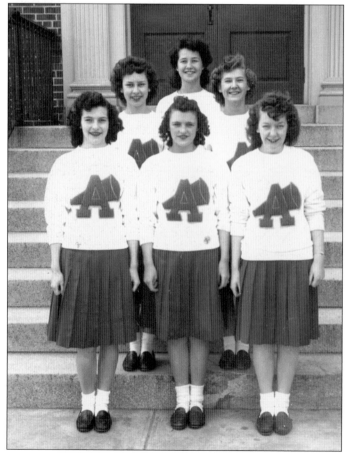

The 1948 Auburn High School cheerleaders pictured here are, from left to right, (first row) Dot Hill, Rita Gallant, and Alice Joyce Carlson; (second row) Claire Gervais and Sally Oslund; (third row) Jean Trombley. (Courtesy of Richard Steelman.)

This picture is from the Auburn High senior prom in 1948. The couples are, from front to back, Richard Steelman and Olive Lawson, Donald Smith and Elaine Remilard, and Charlie Buck and Elsa Baker. (Courtesy of Richard Steelman.)

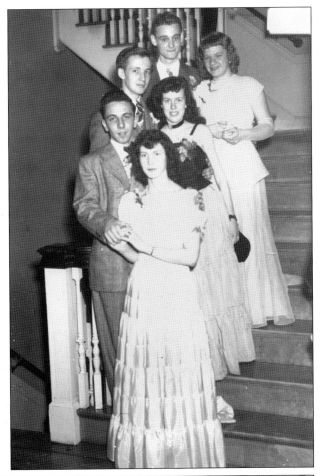

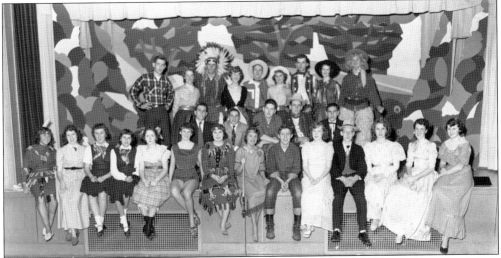

The senior class play, given December 4 and 5, 1953, was *Annie Get Your Gun*. It starred Ann Hastings and Ron Peterson. After high school, Ann and Ron married and had four children; being in the play sparked their relationship. (Courtesy of Anthony Brooks.)

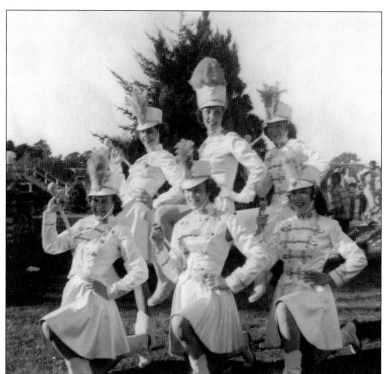

This photograph, taken in 1954, shows the Auburn High School majorettes. They are, from left to right, (first row) Audrey Hamill, Charlotte Millay, and Gail Barron; (second row) Carole Peterson, Arlene Murphy, and Beverly Pelletier. (Courtesy of Sonja Carr.)

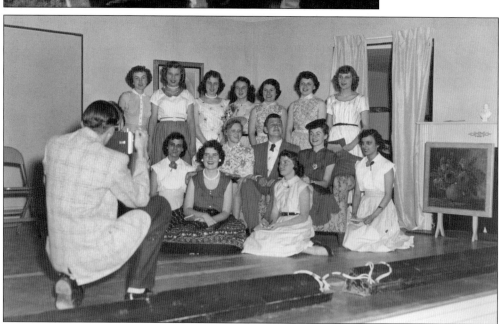

The Auburn High School class of 1955's junior play, *The Bashful Bachelor*, was performed in 1954 under the direction of Margaret Palmer. The partial cast seen in the photograph included, from left to right, (first row) Jean Robitaille, Ann Carlson, and Claire Peterson; (second row) Gayle Schonbeck, Paul Sjosteat, Sonja Baker, and Joan Robitaille; (third row) Patricia Champagne, Carol Skeates, Ethel Roebuck, Phyllis Stewart, Marjorie Bocash, Joanne Kulig, and Carol R. Peterson. The photographer is unidentified but is believed to be from Caisson Foster Photography.

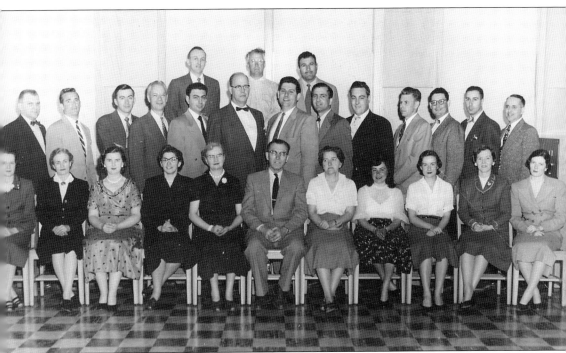

The 1955 Auburn High School faculty included, from left to right, (first row) Margaret Palmer, Isabelle M. Stead, Dorothy R. Mulry, Harriet Brooks, Frances Hogan, Donald W. Goodnow, Mildred L. Young, Rebecca Colokathis, Dorothy Swanson, Mary C. Mannix, and Priscilla Harney; (second row) Howard Besnia, Roger J. Hebert, Ralph A. Leonard, J. Arden Woodall, Francis Fioretti, Gorden B. George, Gerald J. Morin, Robert E. Place, Benjamin Carlin, Erling Hanson, Graenem A. Yoffe, Allison P. Stevens, and Philip Dow; (third row) Leo F. Mullin, George E. Sherry, and Armen Milton.

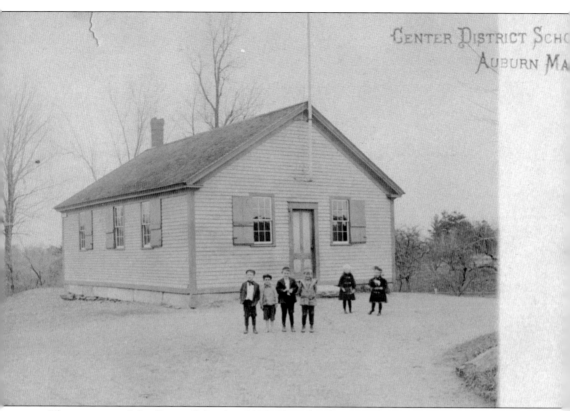

This is a view of the Center School in 1895. There has been a school on this site since the 1700s, when the land was part of Sutton. When the land was annexed to form the South Parish of Worcester, the one-room schoolhouse became known as the Center School. In 1921, the building was moved to Coolidge Street to be used as a house. What was left of the original Center School foundation was incorporated into a two-room school, known as the Tuttle Square School, which was used for many years and is now the Auburn Historical Museum.

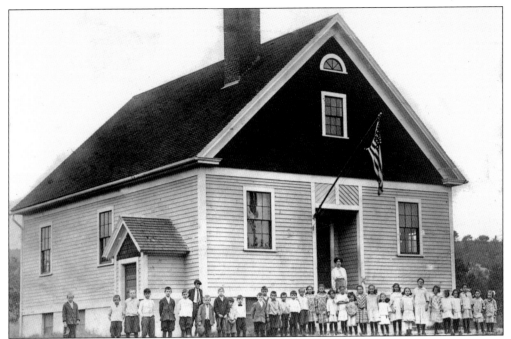

North School is pictured in 1915 at the corner of Rochdale and Burnett Streets. In 1939, it was bought for $550 by J.E. Murray, who renovated it as his home. (Courtesy of Robert Murray.)

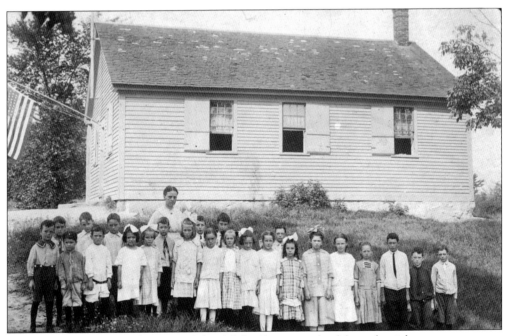

In this 1912 image of Cedar Street School, John Bonzey is third from the right.

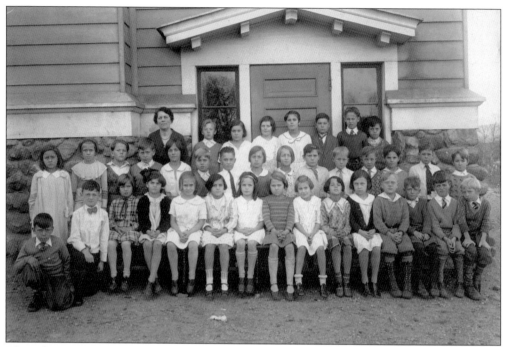

This class picture is from the Elm Hill School around the early 1930s. Madge Magee was the teacher.

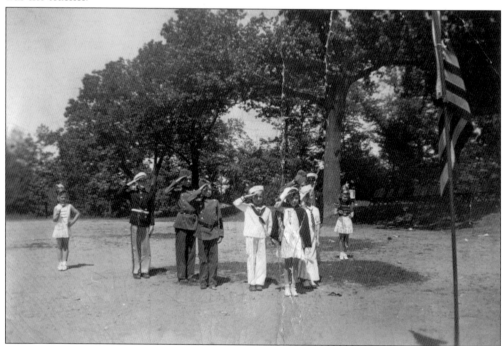

The Auburn youth in this 1942 photograph from a Memorial Day exercise behind the Mary D. Stone School are showing their support for the military and their patriotic spirit. Stanley Johnson is in the sailor suit, and Robert Johnson is in the Marine uniform in the back. (Courtesy of Stanley Johnson.)

This timepiece is from the Stoneville School. The Stoneville School served many children of the mill workers as well as others. It was opened in 1893, and in 1915, a second story was added by raising the first story and adding a new first story below. The photograph on the bottom of page 28 shows this school in the background; the difference between the two stories can be seen clearly. The timepiece is more than 100 years old and is a round drop, schoolhouse-style, eight-day timepiece. It is spring driven in the dewdrop shape. It is not a clock, as clocks have chimes and this does not. The schoolhouse style was so named because they were popular in schools. They had larger, easy-to-read dials so students could see easily how much longer their school day would last.

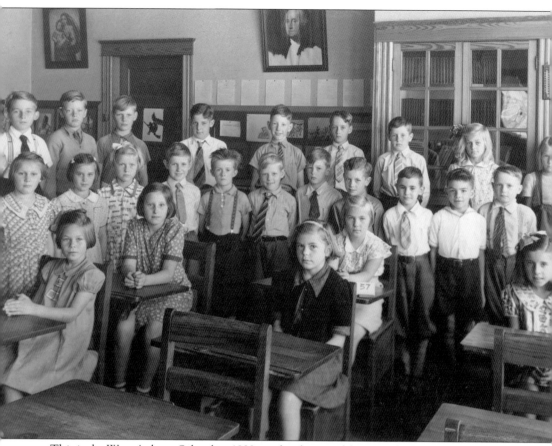

This is the West Auburn School in 1939, grades three and four, taught by Helen Nelson. Pictured are, from left to right, (first row, seated) Peggy Anderson, Gloria Drake, Charlotte Cross, Catherine Kulak, Shirley Weagle, and unidentified; (second row) Mary Jane Berg, Gilda Camosse, Betty Thoren, unidentified, John Mitchell, Roger Prouty, David Sibley, Calvin Steward, Robert Riel, Henry Camosse, and Andrew Drake; (third row) Donald Soponski, Clifford Stevens, unidentified, Henry Weagle, unidentified, Kenneth Ellis, Robert Fox, Barbara Anderson, and Ellen Lukko.

JULIA BANCROFT SCHOOL — AUBURN, MASS.

The Julia Bancroft Elementary School was located on Oxford Street North at the junction with Pinehurst Avenue. The school opened between 1929 and 1930 and was named for the much-loved secretary of the school department. There is no known picture of Julia F. Bancroft, though the Auburn Historical Museum does have a handwritten letter with her signature dated May 15, 1913.

Some of the students in this 1940 Julia Bancroft School photograph do not look so happy to have their picture taken.

85

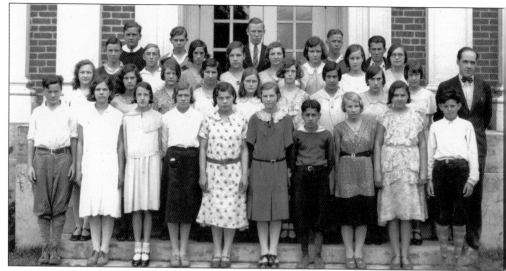

Pictured in this photograph of the 1931 Mary D. Stone School eighth-grade class are, from left to right, (first row) Earl Conant, Ellen Anderson, Marion Poole, Alice Holstrom, Anna Zamis, Elizabeth Gibbons, Sarkis Heghtian, Madeline Nelson, Ellen Gedritis, and Myland Kann; (second row) Elsie Lundgren, Elizabeth Gonyea, Dorothy Kessen, Gunhild Johnson, Adeline Hanson, Beryl Rouke, Rita Robitaille, Lucille Stevens, Signe Bergstrom, and teacher and principal Mr. Roach; (third row) Ralph Conroy, Benny Stearns, Olive Mitchell, Viola Maleskie, Edith Leach, Edith Adshead, Barbara Paradise, and Helen Smith; (fourth row) Forest Place, Stanley Cross, Everett Anderson, Arthur Lind, and Freddy Leclaire.

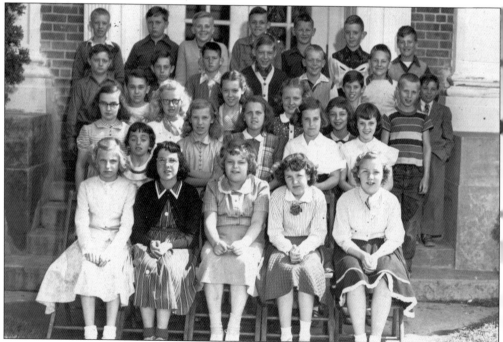

This photograph was taken at Mary D. Stone School around 1955. Many people have forgotten that the school used to handle students through eighth grade. This is a typical class, although the grade is unknown.

These are Auburn High School cheerleaders from 1953. They are Carol Lee Parent, Sally Masterson, Gayle Schonbeck, Elaine Roy, Dorothy Meisner, and Nancy Hill. The mascot being tossed in the air is Paula Scerra. The cheerleaders made their own uniforms. Such school spirit made people glad to be Auburn Dandies.

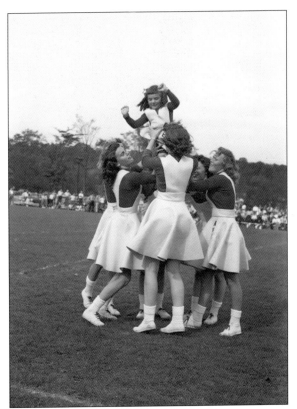

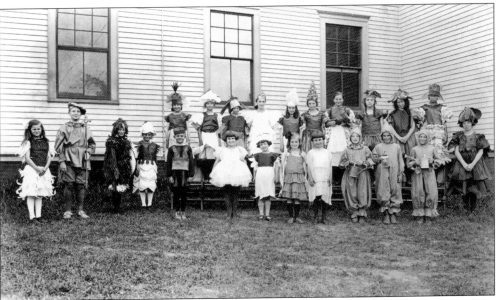

The early part of the 1900s saw many improvements in the town's educational system. The increasing population and development of residential districts caused overcrowding in some of the schools. To ease the problem, some classes were held at the town hall in the 1920s until the Mary D. Stone School was built in 1930. This was one of the classes held there. They were dressed in costumes for a class play.

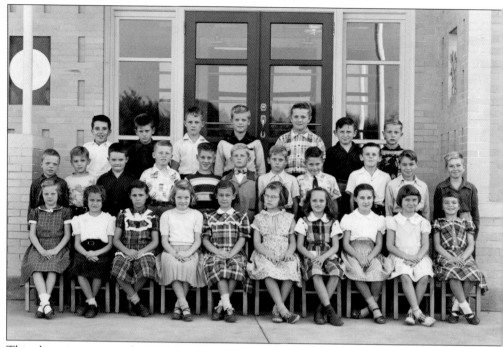

This class picture was taken on October 16, 1951, at the Bryn Mawr School, which is located at 35 Swanson Road. This school was built in 1949.

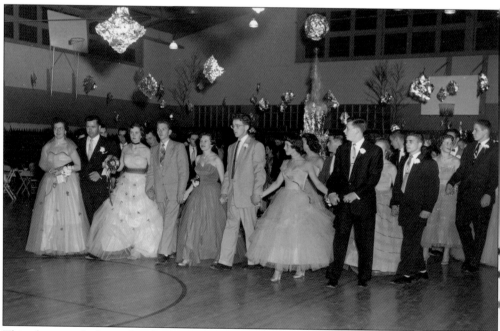

This photograph shows the class of 1955 at its senior prom. The event was titled "Crystal Mist." (Courtesy of Sonja Carr.)

Five

SPORTS AND RECREATION

Auburn has a long history of involvement in sports, though not always in a favorable way. In 1808, a committee was formed to deal with damage that had been done to the meetinghouse windows. It discovered the cause and forbade the playing of ball on the town common. Anyone caught doing so would be prosecuted by the town treasurer. This law was frequently flaunted. Things improved in town after that. As it was illegal to play ninepin in the Colonies, inventive sports lovers added a pin, and tenpin became very popular. The Stoneville and Pondville Mills had a running bowling tournament to honor the end of the Revolutionary War, with their last game being played on January 10, 1840. The ball, made of oak with a solid coating of an enamel-like substance, can be seen at the Auburn Historical Museum. Auburn has only produced one professional sports figure: Al Javery, originally from Oxford, who played baseball with the Boston Braves. The Auburn Cyclones, a semiprofessional football team, was known statewide for their skill and winning ways. The town also boasts two sportsmen's clubs, and Auburn High School sports teams have often won state championships in their division.

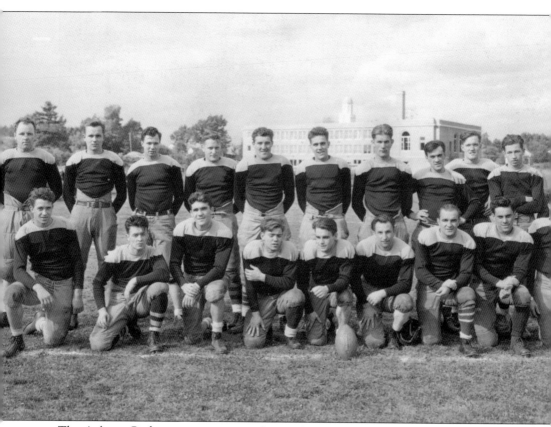

The Auburn Cyclones were a semiprofessional football team during the late 1920s and 1930
founded and coached by Billy May. Most of the games were played at the Auburn Athletic Field
at the site of the current high school on Auburn Street. Some games saw anywhere from 2,000
to 6,000 fans. Eventually, May stepped aside as a player/coach to concentrate on the business
end of the team. He was followed by Thomas Callan, Bud Lavigne, and William Muir, all player
coaches. Over the years, the Cyclones won 72 games, lost 14, and tied 5. In 1939, they became
the Central Massachusetts Champions. Pictured here are, from left to right, (first row) Dan
Scavone, Al Archambault, Jim Harrison, Russell Dickinson, Louis Guerin, Herve Riopel, Milton
LaBarge, Zeke Robitaille, and Fred Bonin; (second row) Cal Ball, Joe Lubin, Dick Nolan, Clark
Carr, George Sturrock, Bud Lavigne, Roy Rylander, Hector Robitaille, Al Leitunikas, Henry
Roussel, and Billy May.

These canvas pants, with leather padding sewn in, and leather helmet were worn by Cyclone Clarence Carr, who played right tackle in the 1930s. He and his wife, Ethel, raised five sons: James, Peter, David, Jon, and Steven. Carr was a director of the Auburn Co-Operative Bank and a member of the school committee from 1947 to 1951. He sponsored little-league teams in Auburn for many years. (Courtesy of James D. Carr Jr.)

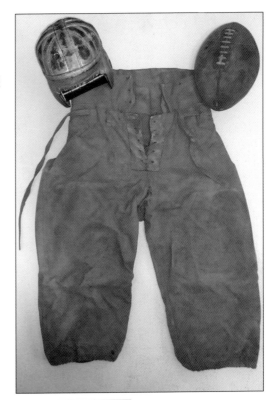

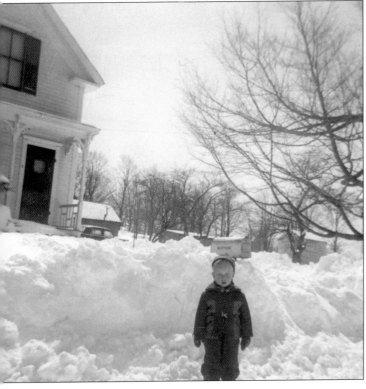

This photograph shows Wayne Bloomquist standing in front of his Stone Street home during a typical New England winter in 1957. Behind him, just visible above the snow, are the barn and the outhouse.

91

The Auburn Kiwanis Club built this entrance to Camp Gleason on Central Street. Pictured here are, from left to right, John Shea, Herb Anderson, John Fahnstock, Roy Persons and Henry Camosse.

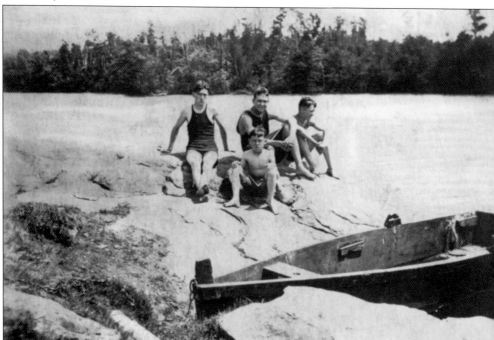

This family group, who were called "the Gang" by friends and family, are shown relaxing on Pondville Pond on July 7, 1925. They are, left to right, Franklin, David P. II, and Eugene Doherty. Leonard Doherty is seated in front. (Courtesy of Elaine Doherty.)

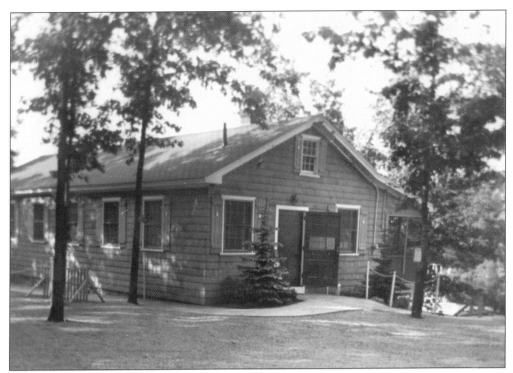

Camp Gleason was made available to the families of the employees of the American Steel & Wire Company of Worcester in the summer of 1941. The camp was officially dedicated on Memorial Day, 1942. There was always a lifeguard on duty, and on slow days, he would give swimming lessons. Families would pack a picnic basket and spend the day at the camp, where there were activities such as swimming, boating, swings, seesawing, fishing, and more. The building above was the snack bar/bathhouse, which was run by Ethel and Eileen Murphy along with friends Alice and Ginny in the early 1940s. Jack Murphy would also sometimes help his sisters. At right, sitting in a rowboat at Camp Gleason, are Ethel Murphy Taubert (left) and Alice Russell Sullivan. (Above, courtesy of John Murphy; right, courtesy of Catherine Staruk.)

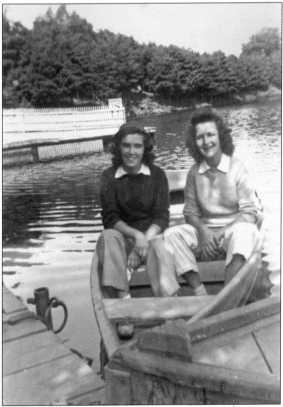

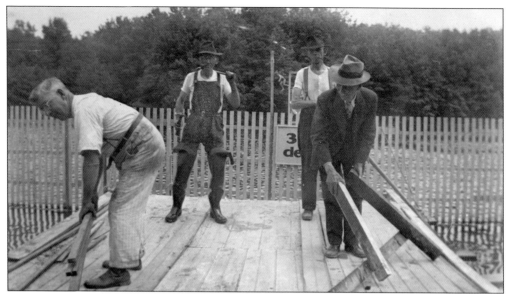

This shows Camp Gleason in 1941. Caretaker Mattie Lennon (left) is explaining what needs to be done in the building of the raft. Once the camp was opened, Lennon would allow some of the older boys to help with camp maintenance, including raking the beach, washing down the bathhouse, or stacking wood. (Courtesy of Catherine Staruk.)

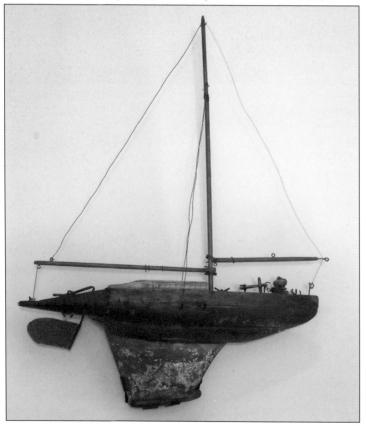

This model boat was built by Norman Hall, Auburn's first military casualty in World War II. As a child, Norman use to sail this boat at Elm Park in Worcester.

Bruce Bouley is shown sliding down the driveway on his family's farm around 1952. Note the barn and hen coops in the background. This was taken on Albert Street in West Auburn. (Courtesy of Richard Hedin.)

This cute little fellow shows no signs of growing up to be a bank director, school committee member, Little League sponsor, and avid supporter of the Boy Scouts of America, receiving the Silver Beaver and Antelope Awards. He was owner of Acme Roofing and Sheet Metal Co. What is easy to see is that he would grow to become a member of the Auburn Cyclones football team. This is Clarence "Clary" Carr. (Courtesy of Sonja Carr.)

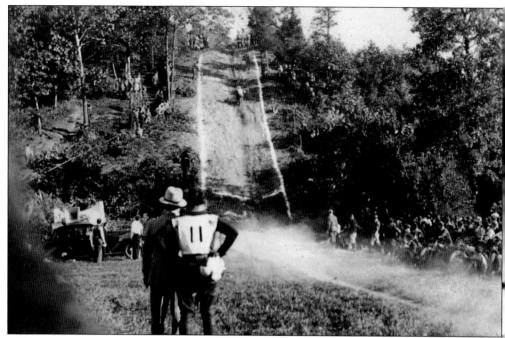

This view is from the bottom of the yearly Auburn Hill Climb, held at Southbridge and Water Streets for many years. Residents who had done this event recount that the Indian motorcycle favored by the Army was the type that made it up the hill most often. This photograph was taken by Brewer H. Webster in 1935. (Courtesy of Janice Webster Brown.)

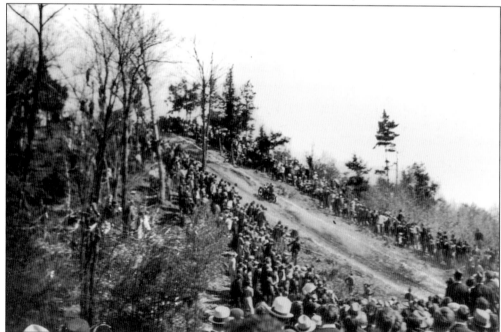

People came from all over the country to participate in and view the races. More than 1,000 spectators could be seen lining the route to watch motorcyclists attempt to make it up the hill. This photograph was taken by Brewer H. Webster in 1935. (Courtesy of Janice Webster Brown.)

Six

CIVIC AND SERVICE ORGANIZATIONS

Auburn has a long and proud history of service, both to the town and to the country. Capt. John Crowl led a company of minutemen to Lexington on April 19, 1775. Once he knew that battle was over, they headed to Cambridge. Capt. Samuel Eddy was a delegate to the Cambridge Convention to help draw up the state constitution. Of 97 men from Auburn who served in the Civil War, 16 perished. Many Auburnites were prisoners of war, held under terrible conditions in places like Andersonville. Others had life-altering injuries. The town boasts of many service organizations, such as the Elks, Rotary, Masons, Women's Club, Junior Women's Club, Knights of Columbus, American Legion, chamber of commerce, Lion's Club, and Kiwanis Club.

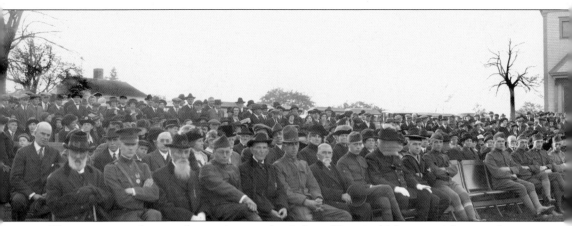

This mysterious photograph was given to the Auburn Historical Museum with no explanation. It was taken by Herbert Bisco of Leicester, a watchmaker and photographer in the 1920s, and is the only known Bisco panoramic shot. It was taken before 1927, as there is no sign of the Mary D. Stone School, built in that year. Based on the dignitaries present, it is believed to show the dedication of the World War I monument in front of town hall. The monument was donated

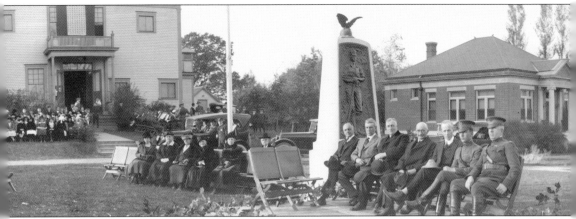

by George H. Sibley, a broker and longtime Auburn resident who died at age 76 in 1921. The gentleman in the Civil War uniform hat seated directly behind the monument is believed to be Joel Prouty, who died in September 1926. Judging by the cars and clothing, this image is believed to date to November 1925.

Andrea Stone and Ruth Allen are shown standing in front of the Grand Army of the Republic (GAR) monument. Erected in 1870, it bears the names of the 16 soldiers from Auburn who died in the Civil War. It was dedicated by fellow veterans of the John A. Logan Post 97, GAR. It is located at the highest point in Hillside Cemetery and can be seen from Central Street. (Courtesy of Diane Moore.)

Chester (left) and Robert Soponski are pictured while on furlough from the US Army in 1944, having come home to assist their mother, Jennie Soponski. (Courtesy of Donald Soponski.)

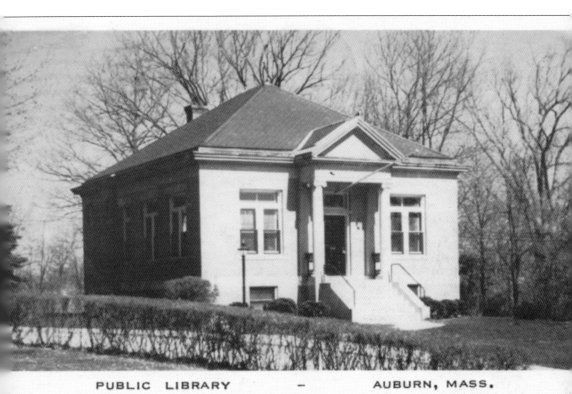

PUBLIC LIBRARY — AUBURN, MASS.

As the town lacked a formal library, many citizens held collections of books in their homes. This changed in 1910, when Leander S. Merriam donated $8,000 to the town for the construction and purchase of the holdings for a library. The gift was made in memory of his mother and father (Ebenezer and Clarissa Merriam) and his sister (Lucy Merriam Hunt), a former librarian. The library was dedicated on June 27, 1911. They only condition attached to the gift was that the building "be free to all religious sects, all nationalities, rich and poor alike." Leander Merriam died on October 4, 1924, at the age of 91—the town's oldest resident—bestowing an additional $5,000 to ensure the maintenance of the building and collections. The mortar stone located in front of the Merriam library was found at the Oxford gore in 1814 and was presented to the town by Herbert Stockwell Merriam and Wright Nelson Merriam, cousins of Leander Merriam. Currently, this building houses the offices of the selectmen and other town officials.

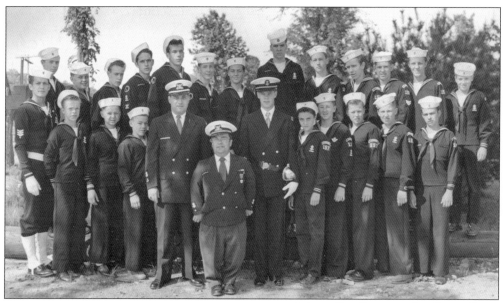

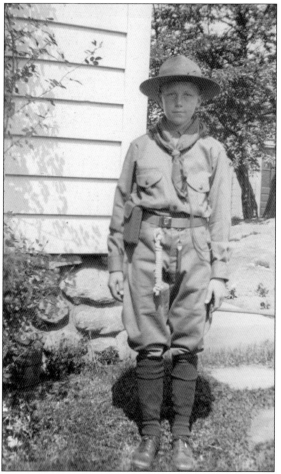

Auburn Sea Scouts in Sea Scout Ship 157 USS *Truxton* are pictured in 1957. The Sea Scouts are part of the Boy Scouts of America. They emphasize activities relating to the sea. They are, from left to right, (first row) Francis Sawicky, Jack O'Connell, John Foy, Edward Cusson, Sidney Shulman, Skipper Harland Fisher, Mate Kurt Sjoblum, Mate David Creelman, Allan McCausland, David Carpenter, Dalton Bickford, and Richard King; (second row) Philip Grennon, Peter Bostwick, Guy Schofield, Robert Kolofsky, James Reid, Albert Laliberte, David Butler, William Reid, Ronald Bonzey, Forest Schofield, Richard Stumpf, Bradley Butler, and Richard Newton.

Richard Warren is pictured in his Boy Scout uniform in the 1920s. Auburn has a long history—nearly 100 years—of Boy and Girl Scouts. The Auburn Historical Museum has a 1918 membership certificate for Girl Scout Ruth E. Stone signed by Juliette Low, the founder of the Girl Scouts. The first Boy Scout troop, 101, was chartered in 1924. Many Auburnites have reached the highest levels in Scouting.

This photograph shows Auburn police officers lining up to enter St. Joseph's Church for the annual "Blue Mass." Leading the procession on the far right is Omer Robitaille. Behind him are Maurice O'Brien, Maybelle Werner, Albert Smith, Fay Congdon, Mr. Upham, Warren Summers, Raymond Tinsley, George Lynch, Bill Whitehead, and Henry LaPlante. Next to Omar is Chief William Cronin. He is leading Julie Laughlin, Leroy Anderson, James Tinsley, George Munger, William Tinsley, Don Grignon, Fred Bonin, and William Gervais. The people bringing up the rear are unknown.

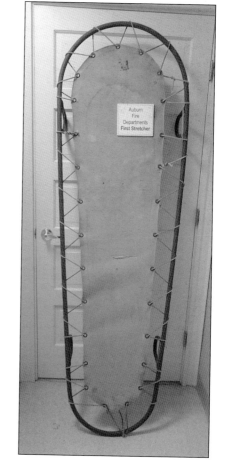

The Auburn Fire Department's first stretcher, from around 1900, is made of canvas roped onto a metal frame. It has metal legs made to fit into slots in a horse-drawn wagon. Note there are no safety straps.

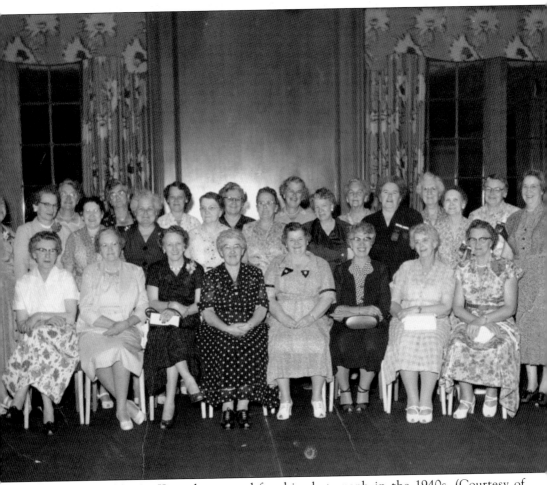

Auburn's World War II mothers posed for this photograph in the 1940s. (Courtesy of Stanley Johnson.)

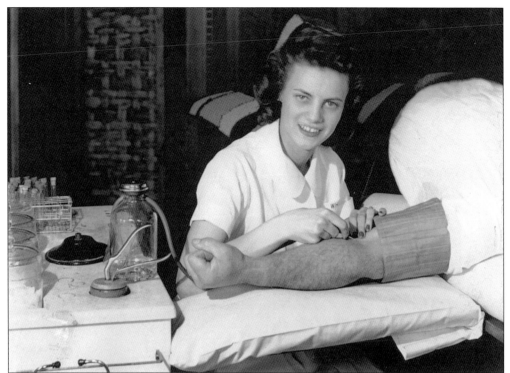

Doris Perron Twarowski, wife of Raymond Twarowski, was a nurse for the Auburn District Nursing Association. She is shown drawing blood at the association's building at 41 South Street, which is now the Auburn Historical Museum. The Auburn District Nursing Association was established in 1919 to serve Auburn residents. (Courtesy of Raymond Twarowski.)

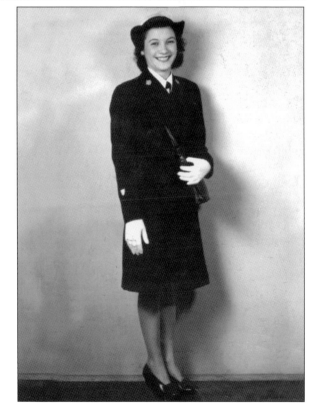

In 1943, Ada Troy became the first woman in Worcester County to enlist in the Coast Guard. She was honorably discharged in 1945. Ada, who lived at Stoneville Heights, performed volunteer work for over 45 years. She was a wonderful singer and often entertained her fellow seniors at the Lorraine Gleick Nordgren Senior Center in Auburn.

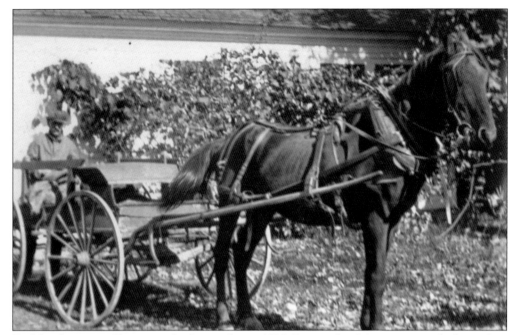

Fred Searle, pictured here, was the fire warden in 1900. Fire wardens' duties consisted of recording damage to land and property by fire in the areas where they lived. Many fires were never recorded, and fires that were recorded mostly occurred along the steam railroads. (Courtesy of Kenneth Holstrom.)

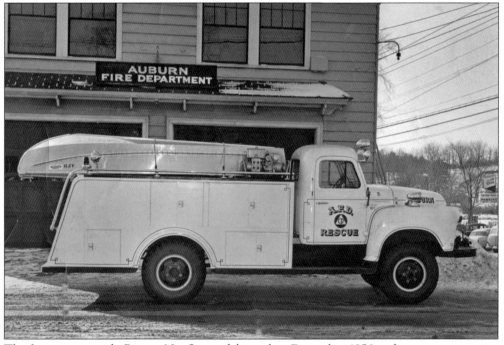

The first rescue truck, Rescue No. 5, was delivered in December 1956 and put into service in January 1957. A portion of the rescue tools was supplied by the Civil Defense Agency. (Courtesy of Kenneth Holstrom.)

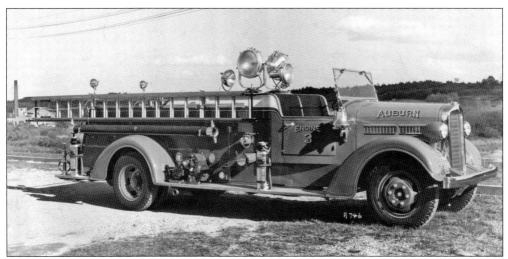

Engine No. 3 is pictured here around 1940. The Maxim Motors pumper was designed with a larger hose body. Areas in town still had limited water resources for extinguishing fires, and this engine could carry more hose to reach some of those areas. (Courtesy of Kenneth Holstrom.)

Posing here are Arthur "Doc" Pierce (left) and Hagop Malkasian. Deputy Chief Pierce was the second Auburn firefighter to die in the line of duty. He suffered a fatal heart attack at a fire in 1961. (Courtesy of Kenneth Holstrom.)

AUBURN
FIRE ALARM

IN CASE OF FIRE DIAL 333
GIVE NAME AND LOCATION OF FIRE

Box	Precinct 1	Box	
11	Worcester Rendering Co.	25	Sumner and Alden Streets
12	Drury Square	212	Stoneville Village
13	Central Square	213	Stoneville School
14	Harrison Avenue	214	Zabelle Avenue
15	Pakachoag and Bancroft Sts.	215	Boyce and Oxford Sts.
16	John Tuck Farm	216	Oxford and Heard Sts.
17	High School	231	Pinehurst Avenue
121	Goddards Farm	232	Wallace Avenue
123	Pondville	234	Burnett Street
124	Stones Crossing	235	Rochdale and Leicester Sts.
125	Maywood Crossing	236	Crowl Hill
131	No. 1 School	241	Oxford and Green Sts.
132	Town Hall	242	Berlin Street
134	Eddy Square	243	Bryn Mawr Avenue
135	Oxford Street, South	244	Leicester Street, West
141	McDermotts Corner		**Precinct 3**
142	West Auburn School	31	High-Lawn Farm
143	West Street	32	Pakachoag St. and Jerome Ave.
144	Tinker Hill Road	34	Malvern Road
145	Hill Street	35	Jerome Avenue School
146	Prospect Street	36	Southbridge St. and Jerome Ave.
147	Oxford Heights	37	Baldwin Chain Co.
151	Merriam District	321	Arnold Road
	Precinct 2	324	Hawthorne Street
21	Auburn St. and Rockland Rd.	325	Southold Road
23	Rockland Rd. and Boyce St.	2	ALL OUT
24	Woodland Park	222	Forest Fire Call

McCRILLIS & KEEP
FIRE AUTO INSURANCE HEALTH ACCIDENT
BONDS
31 AUBURN ST.　　Dial 871　　AUBURN, MASS.

The members of the Auburn Fire Department from 1928 to 1929 include, from left to right, Arthur Pierce, Charles "Dutchy" Berringer, Henry Roberts, Ralph Hardy, Clifton Stone, Herbert Anderson, Vernon Hart, William McMillen, Henry Richard, William McDermott, Everett Rice, Ralph White, and Patrick Foley, who was the first Auburn firefighter to die in the line of duty. (Courtesy of Kenneth Holstrom.)

This alarm card is part of the "phantom box system." Auburn could not afford individual fire boxes to report fires on site in the first half of the 1900s. The town was divided into zones, each with a code, such as 51. When there was a fire at that location, the fire whistle blew five blasts, paused, and blew one blast. Residents could look at their card to see where the fire was.

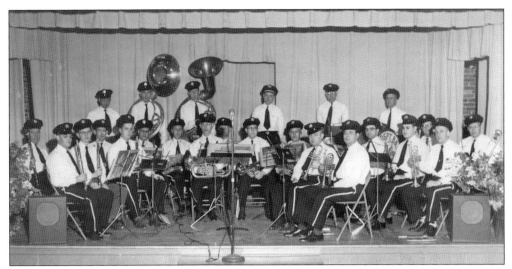

This is the Auburn Fire Department Band around 1952. Robert Giddings Jr. is sitting to the far left in the first row. Other members over the years have included Chester Holstrom, Robert Vickstrom, Alden and Theodore Beauvais, Floyd Holstrom, David "Red" McConnell, and Stanley Pearson. The director was Merton Berggren. The instruments were purchased with donations from local businesses.

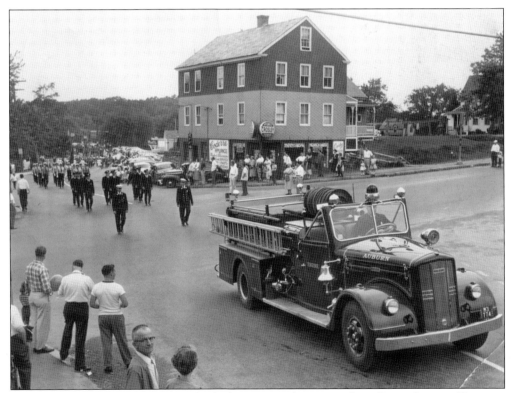

A 1954 Ward LaFrance fire engine leads the Memorial Day parade in Drury Square. (Courtesy of Kenneth Holstrom.)

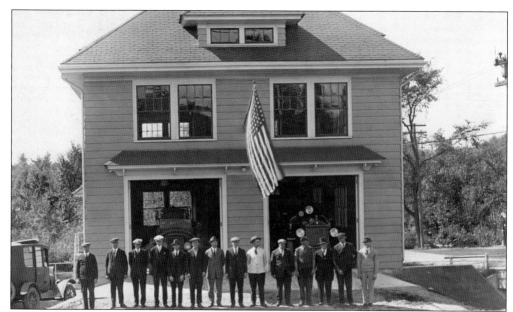

Auburn's first permanent fire barn at Drury Square is shown here. Pictured are, from left to right, Walter Wolfe, Howard Worthington, Everett Rice, Gordon Rice, George Richards, William MacMillan, Vernon Hart, Ralph White, Arthur Pierce, Patrick Foley, Fred Pearson, Charles Berringer, Herbert Anderson, and Henry Richards. Members not present were Levi Croteau, Clifton Stone, Henry Roberts, and William MacDermitt. (Courtesy of Kenneth Holstrom.)

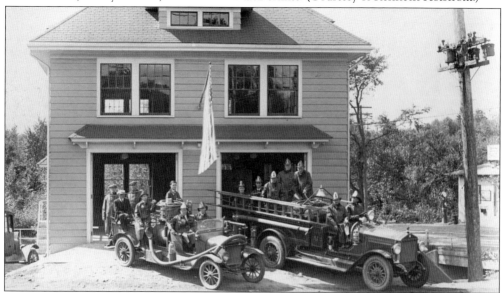

This is the opening of Auburn's first permanent fire barn at Drury Square around 1924. Pictured on Engine No. 1 (left) are Chief Ralph White and driver Henry Richards in the front seat; Vincent LaPrad is the man with the hat in the back, and the others (order unknown) are Walter Wolfe, Herbert Anderson, Ralph Hardy and unidentified. On Engine No. 2 are (left to right) Arthur "Doc" Pierce and driver Levi Croteau in the front. Chief Patrick Foley is wearing the white peaked cap, next to him are Charles Berringer and Henry Roberts. William MacMillan is standing at the back, and the other man is unidentified.

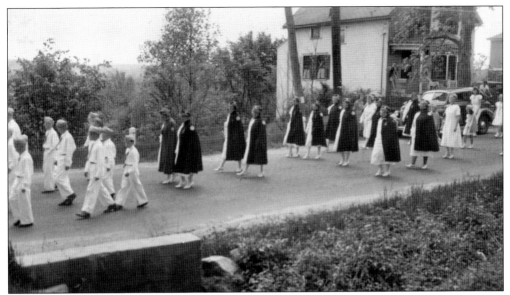

The American Legion Auxiliary marches in a 1939 Memorial Day parade. Here, they are coming down Central Street from town hall. The Warren house is in the background. (Courtesy of Stanley Johnson.)

The police department is shown marching in a Memorial Day parade in 1939. (Courtesy of Stanley Johnson.)

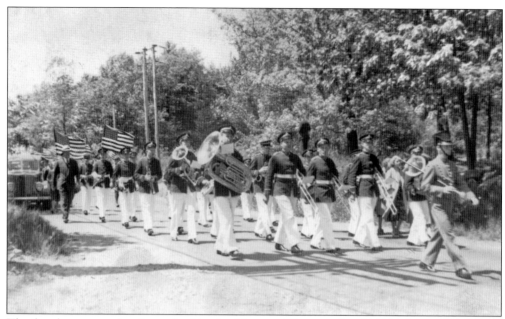

The fire department band marched in the Memorial Day parade of 1939. The Memorial Day parade has always been the largest and best-attended celebration in Auburn. (Courtesy of Stanley Johnson.)

This painted canvas messenger bag was owned by Nathaniel Stone Jr. (1793–1882). The letters WM under the flap stand for "Ward Militia." The Ward Company of Massachusetts was established in 1787 and enrolled militia until it was disbanded during the 1840s.

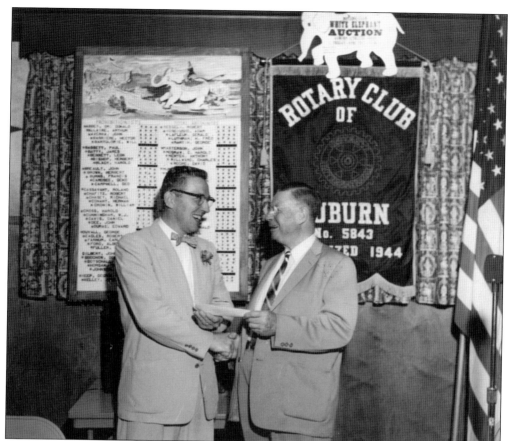

The Auburn Rotary Club was established in 1944. Jesse J. Morgan, Auburn's school superintendent, was its first president. Shown here are president Donald T. Taylor (1957–1958, left) and past president George M. Duval (1946–1947, right). (Courtesy of Raymond Twarowski.)

This original uniform, donated by Ronald E. Prouty, was worn by Auburn resident Joel H. Prouty during his service in the Civil War. The Joel H. Prouty Lodge of Masons was named for him in 1927.

MASONIC TEMPLE — AUBURN, MASS.

The Joel H. Prouty Lodge Masonic Temple, instituted on March 27, 1927, was originally located at 81 Hampton Street above. The Order of the Eastern Star, Pakachoag Chapter No. 224; the Order of Rainbow Girls, Auburn Assembly No. 68; and the Auburn Chapter Order of DeMolay also met there.

This is the celebration of the 75th anniversary of the Auburn Grange in 1949. The Auburn Grange was active over 125 years, granting scholarships and organizing recreational and educational activities for the whole town. In the photograph are, from left to right, (first row) Margret Reed, Gretchen Nordstrom, Philip Warren, Mabel Hensly, Majorie Stone, Ira Lutes, Abbie Wiley, and Elizabeth Hoyle; (second row) Raymond Warden, Donald Reed, Elward Hallberg, Canci Riley, Agnes Warden, Gerald Smith, Fred Hardy Jr., and Elmar Hallberg.

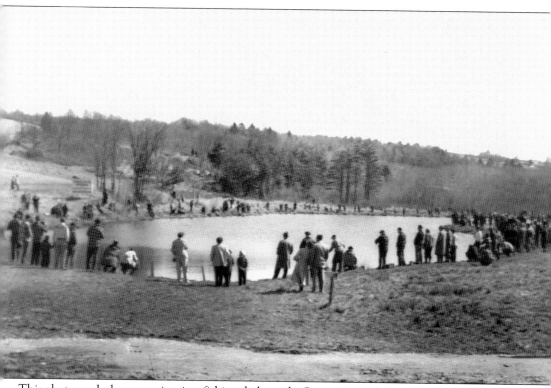

This photograph shows a springtime fishing derby at the Sportsman's Club on Elm Street. Founded in 1932, the club provides a clubhouse, barbecue area, shooting ranges, and a stocked pond for fishermen. It also has social activities for members and their families, and the grounds are used by many organizations for special outings and events.

Earl Standring had a fervent love for the American flag and a dream to make his hometown known as "Flag Town U.S.A." This was realized in 1958 after a two-year campaign with the help of the civic organization in town. Earl was a mailman in town and an avid square-dance caller. He was also an Explorer Scout leader with Troop 53 at St. Joseph's Church.

Abbie Wiley was the leader of Camp Fire Girls and Girl Scouts for 40 years; she also led the 4H Club. She was a World War II air raid warden and served as the First Congregational Church Sunday school superintendent for many years in addition to her involvement on numerous committees. Here, she poses with Camp Fire Girls on the porch of her South Street home. The girls are, from left to right, Sonja Baker, Carole Peterson, Marcia Newton, and Nancy Connors. (Courtesy of Sonja Carr.)

Auburn's town hall was dedicated on November 12, 1896, before a large and appreciative crowd. There was a supper following the dedication, with dancing and other celebratory activities. Before the facility was built, town activities were guided from the basement of the meetinghouse and, later, from the home of the town clerk. Due to danger of fire, most town clerks chose to keep the records in their homes up until World War II.

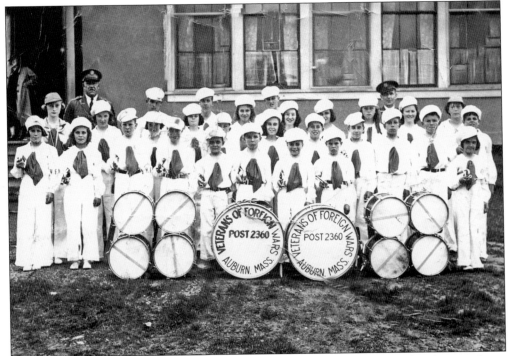

This is the Veterans of Foreign Wars Drum Corps from 1938. Appearing in the photograph are Rita McMenemy, Mae Mathieu, Esther Fegrues, Anna McMenemy, Earnest Burnett, Helen Marie Peterson, Alfred Porter, Robert Peterson, Eleanor Cronin, Louis Kuhn, Paul Mathieu, Jimmy Mullaney, Claire Fegrues, Franny McMenemy, Ethel Murphy, Carl Landin, Viola Benoit, Gene Escolas, Milton Landin, Catherine Murphy, John Cronin, George Kuhn, Muriel Wells, Russell Sivret, Mary McMenemy, Bill McMenemy, Dot Wells, Eileen Murphy, James Cronin. Standing in back are Franklin Sivret and Jack Murphy; "Gramma Sivret" is on the steps.

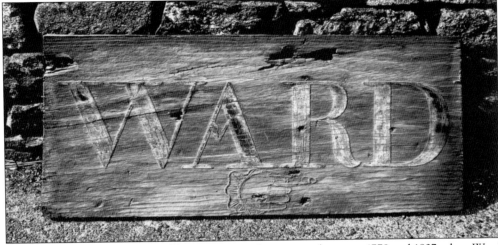

This original street sign from Millbury was erected some time between 1778 and 1837, when Ward became Auburn. It was lost for many years until Robert Pearson of Pearson's Dairy was in his cellar, looked up, and saw the sign being used to stop the floor from creaking. The letters are hand carved out of the background to make a beautiful relief-carved sign. (Courtesy of Robert Pearson.)

Seven

TRAINS, TROLLEYS, AND PINEHURST PARK

The first train to Auburn was the Great Western Railroad in 1839, which went from Worcester to Springfield. It was used for both goods and passengers and, traveling at 15 miles per hour, was the fastest mode of transportation at the time. It was very uncomfortable and messy, and the passengers rode in an open stagecoach supported by metal hangers. The wood-fired locomotive sent soot into the open coach, and sparks from the engine often set clothing on fire while changes in speed sent passengers sprawling. The Worcester & Norwich line came through in 1840, connecting with the boat train, a steamer taking passengers to New York City. This extremely popular line ran for approximately 100 years. It had a passenger and freight station on Auburn Street, which is in use today as Golden Pizza. At the time of the Civil War, the Great Western became the Boston Albany line.

The Worcester & Webster Street Railway (trolley) came in 1897, and the Southbridge Street Railway line arrived in 1902. They carried commuters and students; as Auburn did not have a high school until 1935, students had to travel into Worcester to continue their educations. The two trolleys had a joint venture, Worcester Consolidated, to bring mail into town and take the dairy farms' milk out of town. Auburn was the first town to put a freight car behind a trolley to haul coal to the Overlook Hotel in Charlton.

Pinehurst Park was an amusement park established around 1903 in response to the trolley companies' call for attractions to encourage people to use the trolleys on the weekends. Pinehurst Park had a midway, a theater seating 2,500 people, picnic groves, and a scenic railway with indoor scenes depicting heaven and hell. Pinehurst Park's scenic railway, part dark ride and part roller coaster, was said to be the largest in the world. A huge draw was the fact that Pinehurst Park boasted electric lighting. The park thrived for seven years until Worcester gang activities forced it to close. Auburn had no police force large enough to handle those problems at that time.

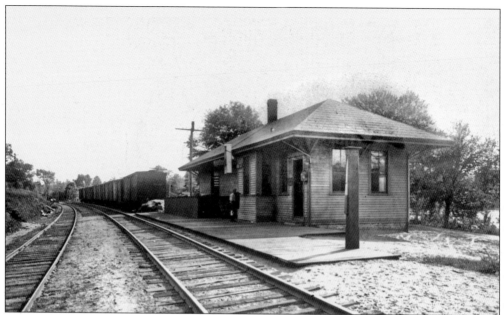

This is a 1913 picture of the New York, New Haven & Hartford Railroad station, which has been on this site since the 1840s. It closed in 1965 and became a flag stop after that. Freight was also offloaded at this station. Today, it is a pizza shop. (Courtesy of Raymond Twarowski.)

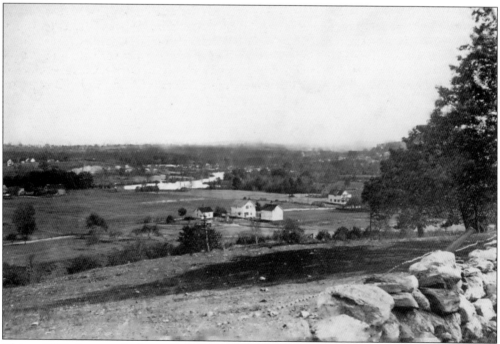

This c. 1902 photograph shows Stoneville Pond and Stoneville from the Hebrew Cemetery. It shows the electric trolley tracks and the power station in the background, but Pinehurst Park was not yet built. (Courtesy of Robert Haroian.)

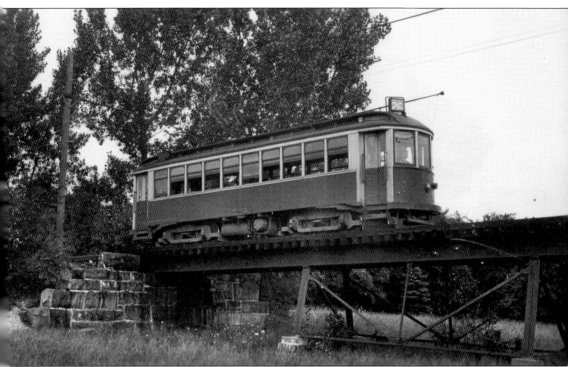

This 1935 photograph shows the West Auburn trestle, completed in the summer of 1902. Here, the trolley goes over the Boston & Albany Railroad line, Webster Branch. Due to state laws, it was very difficult and time consuming to have a trolley cross railroad tracks. The trolley would have to stop, and the motorman would have to get out and be certain no train was coming. Thus, the elevated trolley trestle was built to pass over the train tracks to avoid a grade crossing. Once automobiles became common, the trolleys were less used and were eventually discontinued. This trestle, located near Blaker Street, was dismantled for scrap during World War II. (Courtesy of Philip Becker.)

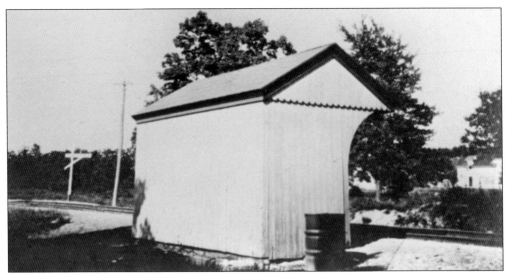

The Maywood Crossing train stop was located at the corner of Cedar and South Streets in 1916.

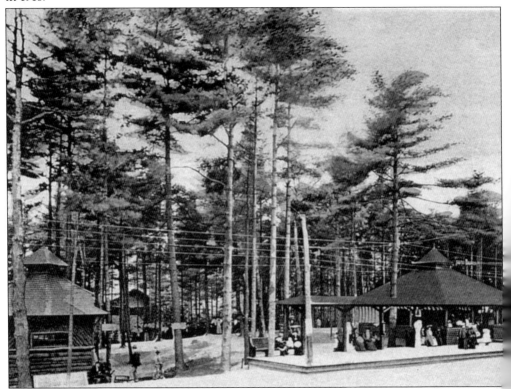

The raised trolley platform at Pinehurst Amusement Park is clearly visible in this old photograph probably taken in the early 1900s. The platform is properly called the "waiting station." The photograph was taken looking west into the amusement park itself. The park began at the intersection of Oxford Street and Pinehurst Avenue and extended about 2,000 feet toward Worcester. While most traces of the park are now gone, some of the garages on Pinehurst Avenue were once concession stands.

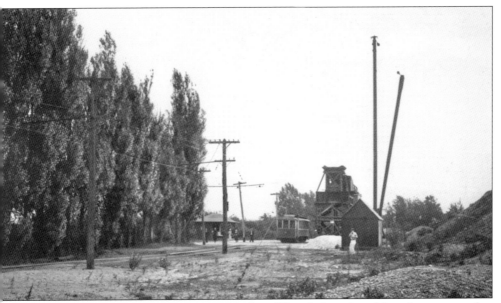

This is a 1935 picture of the Worcester Street Railway West Auburn line. Note the stone crusher on the right, in front of the trolley car. The machine, which crushed large stones to make beds for railroad ties, ceased operation in 1927. The ruins of the crusher can still be seen today. (Courtesy of Philip Becker.)

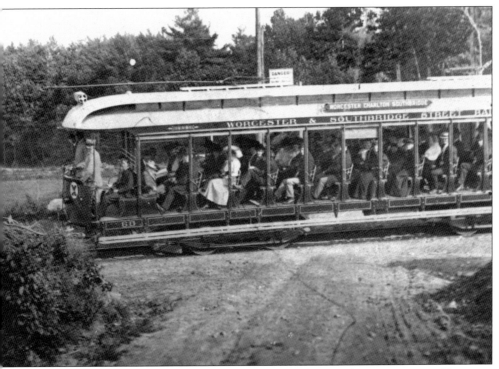

This is an open-air summer trolley car on the Bryn Mawr line at the intersection of Leicester Street, which was known as Twin Oakes Crossing long ago.

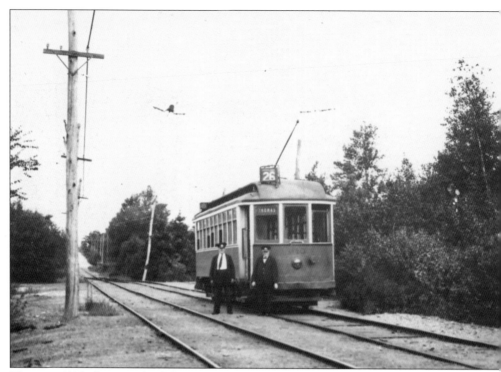

This is a 1935 photograph of the Worcester Street Railway No. 810, West Auburn line. The motorman is Robert Anderson, on the left. (Courtesy of Philip Becker.)

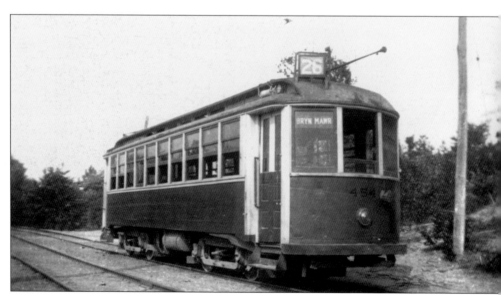

This is a wooden suburban car of the Worcester Street Railway, Bryn Mawr line. (Courtesy of Philip Becker.)

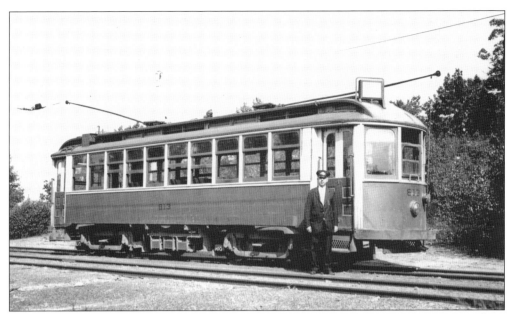

This photograph was taken on September 1, 1935, and shows of the Worcester Street Railway No. 813, West Auburn line, Bryn Mawr extension. N.V. Mulstay is the motorman. (Courtesy of Philip Becker.)

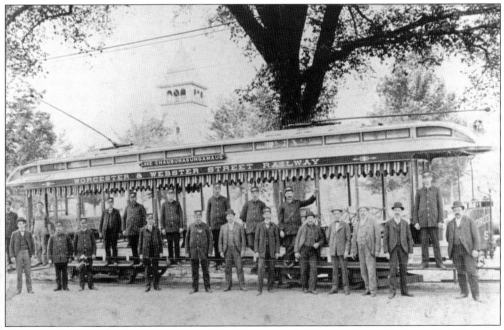

This is a photograph of a summer car of the Worcester & Webster Street Railway. This line ran down Central Street through Auburn Center. The name of the car, *Lake Chaubunagungamaug*, is the abbreviated name of an important lake in Webster. The alternate—and official—spelling is 45 letters long, making it the longest place name in the United States. This photograph is from the late 1800s.

AUDITORIUM, PINEHURST PARK, WORCESTER MASS.

Pictured above, the Rustic Theater at Pinehurst Amusement Park held 2,500 people. The seats were divided into sections; the 5¢ and 10¢ seats each held 1,000 people, while the 15¢ seats held 500. The photograph below is also from Pinehurst Park, which existed from approximately 1903 until 1910. It was built at the request of the Worcester & Southbridge Street Railway. The trolleys had to keep steam up seven days a week, and they wanted towns to build attractions so people would ride the trolley on the weekends. The park also had picnic areas, some water attractions, such as boating and swimming, and a giant midway, and thousands of people came from Worcester and surrounding towns to enjoy it. The big attraction was this scenic railway. The ride took people through depictions of paradise, Hades, fairyland, Yellowstone Park, and other interesting scenes. It was built at a cost of $17,000 and was the largest of its kind in New England. It held 64 passengers, and the ride took nine minutes.

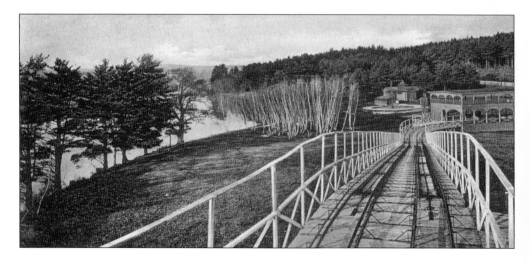

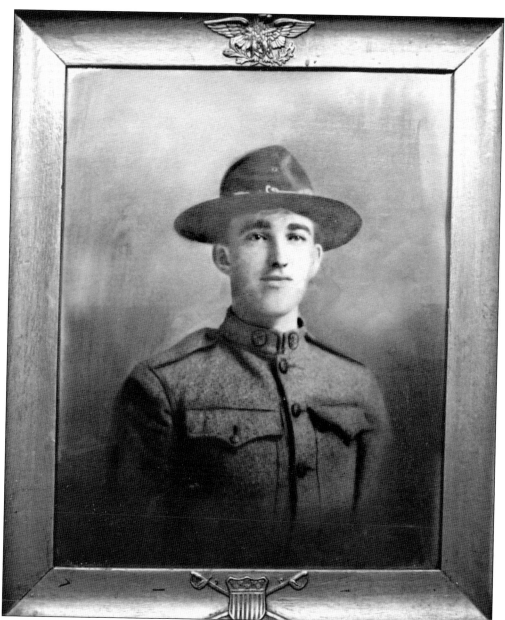

Chester P. Tuttle was the first man from Auburn killed in World War I. Born in 1895, he worked on a farm in Auburn until he enlisted in the Army on October 6, 1917. He trained at Camp Devens, Massachusetts, went for more artillery training in Georgia, and was shipped overseas in May 1918. He was wounded in France on October 31, 1918, and died the following day. He was buried in France, but his body was brought home in 1921. Services were held at the First Congregational Church, where he was a member. He was buried in Hillside Cemetery. As was the custom, the local American Legion post, 279, was named for Chester P. Tuttle in 1922, and it is very active in town today. (Courtesy of the Chester P. Tuttle Post 279, American Legion.)

Discover Thousands of Local History Books
Featuring Millions of Vintage Images

Arcadia Publishing, the leading local history publisher in the United States, is committed to making history accessible and meaningful through publishing books that celebrate and preserve the heritage of America's people and places.

Find more books like this at
www.arcadiapublishing.com

Search for your hometown history, your old stomping grounds, and even your favorite sports team.